T0053761

PROCEEDINGS OF THE

AMERICAN ACADEMY

OF ARTS AND LETTERS

PROCEEDINGS

OF THE

AMERICAN ACADEMY OF
ARTS AND LETTERS

SECOND SERIES · NUMBER SIXTY

NEW YORK · 2009

PUBLICATION NO. 535

TABLE OF CONTENTS

PART ONE

PART TWO

PART THREE

PART FOUR

PART ONE

Ceremonial

of the

American Academy

of Arts and Letters

May 20, 2009

Opening Remarks
by J. D. McClatchy
President of the Academy

G OOD AFTERNOON, ladies and gentlemen. My name is J. D. McClatchy, the newly elected president of the American Academy of Arts and Letters, and I want to welcome you to the Academy's 68th Ceremonial, along with our honorees, members-elect, and special guests. The first of these awards ceremonies was held in 1941, and among the academicians sitting on the stage were William Faulkner, Robert Frost, Samuel Barber, John Sloan, Eugene O'Neill, Willa Cather, and Sinclair Lewis. But of course the Academy has had a much longer history, and at its first public meeting in 1900, the membership included Henry James, Theodore Roosevelt, Augustus Saint-Gaudens, Albert Bierstadt, John Muir, Daniel Chester French, Edward MacDowell, Bret Harte, Childe Hassam, Woodrow Wilson, and Mark Twain. This stage has, in fact, been a kind of diorama of American culture over the past 111 years, reflecting its ambitions and achievements. From the start, the honor of election was considered the highest form of recognition of artistic merit in this country. It still is. But since 1941, the Academy has also been reaching out to reward and encourage extraordinary achievements of the imagination all across the nation.

We do so again today, but at a time of real crisis for arts organizations everywhere. Greed complicit with stupidity has caused a menace to the financial economy whose impact is global, and

whose effects have severely damaged the arts community. Symphony orchestras and opera companies have shut down or cut back, exhibitions and theater pieces have been cancelled, publishing is crippled, commissions and grant money have dried up, endowments have been decimated, and donations have disappeared. When an event is cancelled, it is not only the artist who suffers. So do the thousands of individuals whose livelihoods depend on the arts—from typesetters, stagehands, dressers, singers, and dancers, to copyists, designers, advertisers, office personnel, and ushers. Victimized as well, of course, are readers and audiences.

There is, at the same time, a new feeling of cautious hope across the land—hope for leadership that will both solve problems and re-establish a sense of balance and responsibility. The arts have a crucial role to play in such an urgent moral drama. As custodian of any culture's memories, they embody and guard traditions. Lincoln Kirstein once described the repertory of his ballet company as a patrimony, and added—in words that apply equally to an art form and an individual artist—"The expression of a sensibility is present as a continuum, to be seized upon by important possibilities." Both old traditions and new possibilities, each dependent on the other, are the dynamic that art offers to society as a model and as an inspiration. At a time in our national life of explosive and far-reaching change—from the mix of our population to the status of our international role to the ambivalent reach of technology—art's ability to question social forces and to portray the self's deepest anxieties and yearnings is more important than ever.

It is the artist's job to put pieces of the past and future together, to re-arrange our expectations, to disconcert our presumptions, and to discover new feelings. It is the artist's job to remind

us what we have been and suggest what we may become. It is the artist's job to give uneasy and radiant pleasure, to lead the mind down crooked corridors of speculation, to complicate our lives, not to soothe them, but also to console with its stark beauty. It is the artist's job to witness, to question, to entertain, to praise, to surprise, to scare, to enthrall.

To say that all this is threatened by a world crisis is also to exaggerate, when we should be reminding ourselves that we are privileged to live in a country which has always (if sometimes reluctantly) valued art, and in a society which has generously supported artists. Our good fortune was thrown into wrenching relief for me when I read the late Ryszard Kapuscinski's book, *Travels with Herodotus*, where he describes his life as a first-year university student in Warsaw in 1951.

There were no textbooks. There were no books at all; libraries had all been destroyed. As children of the war, they had not gone to high school—the schools were closed. There were no museums or concerts—just stories whispered by the elders. Kapuscinski for some reason wanted to become a historian, and had heard the name of the first great Greek historian, Herodotus. In the 1940s Herodotus's *Histories* had been translated into Polish, but the manuscript had been locked up for fear that—in an atmosphere where every allusion was interpreted darkly—Russian authorities would construe its accounts of ancient tyrants as a slur on Stalin, and thereby incite his wrath. His classmates—the children of workers and peasants were given preference—were emaciated and largely illiterate. Yet one day their professor showed them tattered old photographs of ancient statues and vases—with Greek figures, noble, elongated, athletic, mythic, "a world of sun and silver." For the first time, and nervously, the young man dreamt of elsewhere, though there was nothing to

take him there. He longed for anything different, but was fearful that reaching for it would change him. No one took risks, no one complained, everyone glumly waited—for what, they did not know.

That was just two generations ago, easily within the lifetimes of many sitting here today. The threats in a free, advanced society like ours—where elsewhere is everywhere, and where difference is the order of the day—here the threats are less clear, but can be just as pernicious. The allure of Google and iTunes is palpable, but so are the threats they pose to copyright and to artistic integrity. The Academy strives to protect the national inheritance that American art has been, is, and will be; to see that all Americans have access to it and know how to learn from it. And it is our job to protect the artist, not as a commodity but as a conscience, as a creative force within a democratic society.

I mentioned the sense of hope abroad in the land and want to read to you a letter that arrived at the Academy this morning from the White House:

> I send my warmest greetings to all who are celebrating the richness of the arts and their importance in American life. The breadth of our Nation's diversity has infused our arts and letters with a unique creative style, distinctive in form and theme. Our composers, artists, architects, and writers have formed a body of work that is truly our own, treasured not just within our shores, but appreciated and loved by a global audience. Tonight, as you honor these creative contributions, I thank you for your good works and for the joy and meaning they bring to our citizens and to the world.
>
> Barack Obama

And now we come to the happy business of the afternoon—the celebration of art at its most inventive and compelling. Before we begin, though, let me take note of both an unfortunate accident and a pleasant coincidence. Those of you who attend this ceremonial regularly are used to a pre-ceremonial recital on this auditorium's world-famous organ. Today, in fact, Dorothy Papadakos was to have played music by Victor Herbert, the 150th anniversary of whose birth is being celebrated this year. Victor Herbert was also a member of the Academy, having been elected in 1908. But just the other day, we discovered some water damage that sadly precludes the instrument being played. On the other hand, I'd like to point out that several former Academy presidents are on stage this afternoon—Louis Auchincloss, Ezra Laderman, Philip Pearlstein, Ned Rorem, and Kevin Roche.

Now to begin. . . .

Induction of Foreign Honorary Members by the President of the Academy

I N 1929 the Academy sought to strengthen cultural ties with other countries by electing 75 persons of great distinction in architecture, art, literature, and music to Foreign Honorary membership. I have the honor to induct three Foreign Honorary members. Two of them could not be with us today, the renowned English playwright Caryl Churchill, and the German artist Sigmar Polke. Their insignia have been sent to them. But we are delighted that the third of our new Foreign Honorary members is with us today, and I would ask the distinguished architect David Adjaye, now London-based, but born in Tanzania of Ghanaian parents, to step forward. We are very grateful to Mr. Adjaye for having made a great effort to join us today—he's just off a plane from Denver.

DAVID ADJAYE has been described as one of the most exciting and accomplished young architects to emerge on the international scene. In his architecture practice, Adjaye aims to develop what he calls "an artist's sensibility." He is the architect of the Denver Museum of Contemporary Art, won the competition to design the Nobel Peace Center in Oslo, and will design the National Museum of African-American History and Culture that is scheduled to open in 2015. His work is characterized by an extraordinary conceptual clarity combined with a graceful embrace of contradiction.

The dialogue usually seems natural, but with their first, crackling exchanges, CARYL CHURCHILL's* characters disengage us from the banal and send us soaring. Her plays are like exploratory space modules, each designed to examine with its own specific instruments and criteria the laws of an unfamiliar planet (ours). Although Churchill's capacity for invention is apparently inexhaustible, her inventions share an unmistakable and uncanny harmony of analytical rigor, dangerous humor, and visionary beauty.

SIGMAR POLKE* continuously challenges the practice of painting, for example, in his inquiry into the art of alchemy. He thumbs his nose at and makes fun of conventional ideas of art and social behavior. A forerunner of artists like Martin Kippenberger, Mike Kelley, Paul McCarthy, and Franz West, he is a seminal influence on young artists today.

*Not present.

Induction of Members
by the Secretary of the Academy

J. D. McClatchy introduces Rosanna Warren.

Rosanna Warren:

May I ask each new member to come to the lectern when I read his or her name.

IN ART

JUDY PFAFF frees sculpture from gravity's moorings to create atmospheres, restless levitations, and drawings in space. Her installations combine carefully crafted elements of her own making with found materials, both man-made and natural, to create protean forms of rich and ever shifting complexity. While primarily a sculptor, Judy Pfaff's ideas are expressed in equal fluency and power in her drawings and prints.

The work of TOD WILLIAMS, in partnership with Billie Tsien, is disciplined, inventive, and meticulously detailed. His projects bespeak propriety born of intellect, audacity born of intuition, and felicity born of love of the craft of building.

IN LITERATURE

The novels and short stories of T. CORAGHESSAN BOYLE are distinctive for their adventurousness, their sharp, multifaceted style, and their mordant empathy. In a lengthy and productive career, Boyle has been a comi-tragic original who shows no signs of tapering off or losing his edge.

JORIE GRAHAM has been a poet of eager inventiveness in line, stanza, voice, and narrative. She has written about the several overlapping identities in men and women alike; about natural phenomena and their mutating processes; about American and European paintings; and about war, motherhood, the ancient past, and the philosophical questions posed by past writers and artists, whether Pascal or Magritte. She has avoided repeating herself in her evolving and transformative art.

The poetry of YUSEF KOMUNYAKAA is able to do what so little recent poetry can do: tell you what it's like to live in America, what it's like to grow up in Jim Crow Louisiana, what it's like to spend a chunk of one's young manhood as a combat soldier in Vietnam and to come back to a nation that has no use for you. The people, the cities, the landscapes, the music of this country are in his work. How he finds the capacity to love them all is one miracle, another is the delicacy with which he goes about making his stunning poems. He is a writer of original force.

RICHARD PRICE's novels dwell within the American urban underclass. His characters have a Hogarthian vividness, and implicit in their transgressive acts and beleaguered relations with one another is a gritty understanding of The American Dream. Price renders their lives with both unsparing precision and great compassion. A literary descendant of James T. Farrell and Richard Wright, this dazzlingly gifted and very smart writer steps up to a level of literary practice that might be called lyric naturalism.

IN MUSIC

Few composers have achieved as distinctive, as authentic a voice as STEPHEN HARTKE. He somehow makes each instrument

he writes for sound as if we have never heard it before. He has tackled the big genres—symphonies, concertos, opera—and made them thoroughly his own. But he has also subverted tradition to invent lively, enchanting sound-worlds we never knew existed. We perk up our ears, delighted.

American composer and virtuoso pianist FREDERIC RZEWSKI has challenged and transformed contemporary music. His early masterworks, *Coming Together, Attica,* and *The People United Will Never Be Defeated!,* have been followed by a powerful stream of influential compositions: *North American Ballads, De Profundis,* and *Pocket Symphony,* etc. In his own unforgettable performances and those of his contemporaries Paul Jacobs, Ursula Oppens, The American Composers Orchestra, and younger colleagues Lisa Moore and Eighth Blackbird, he has created an indelible legacy of provocative, beautiful, uncompromising music.

AUGUSTA READ THOMAS's impressive body of work embodies unbridled passion and fierce poetry. Championed by such luminaries as Barenboim, Rostropovich, Boulez, and Knussen, she rose early to the top of her profession. Later, as an influential teacher at Eastman, Northwestern, and Tanglewood; chairperson of the American Music Center; and the Chicago Symphony's longest-serving resident composer, she has become one of the most recognizable and widely loved figures in American music.

Presentation of Arts and Letters Awards
in Architecture by Billie Tsien

J. D. McClatchy:

As I mentioned earlier, it was 68 years ago that the program to give Academy awards to Americans in Art, Literature, and Music was begun. Three Academy awards in Architecture were added much later. The Academy awards, given in recognition of outstanding artistic achievement, will be presented by the chairman of each award committee. Nineteen Academy awards, of $7500 each, are being given today.

Billie Tsien:

The other members of the 2009 Award Committee for Architecture were Henry N. Cobb, Peter Eisenman, Michael Graves, Hugh Hardy, Steven Holl, Ada Louise Huxtable, Richard Meier, and James Polshek. Two of the Academy Awards in Architecture were created to recognize an architect whose work is characterized by a strong personal direction.

STAN ALLEN deploys a consummate knowledge of his discipline, unusual for an architect, to lead what is clearly one of the two best schools of architecture in the country.

WENDELL BURNETTE is that rare architect who truly understands how buildings are made. He knows what is possible. He is also an impassioned searcher and his searching brings all his work to that magical place where possible and impossible are in

equilibrium. His buildings sit on the earth with the calm authority which comes from making the world a better place. Rigor and joy are in a quiet and profound conversation.

In 2003 the Academy inaugurated an Academy Award in Architecture which recognizes an American who explores ideas in architecture through any medium of expression. This year the Academy is giving one of these awards.

Over the past quarter-century, JEFFREY KIPNIS has made a significant contribution as teacher, critic, and theorist to the discourse around architecture. His contribution has been characterized by penetrating speculative insights coupled with clarity of expression, and by acute critical judgments coupled with unfailing generosity of spirit.

Presentation of Arts and Letters Awards in Art by Varujan Boghosian

J. D. McClatchy introduces Varujan Boghosian.

Varujan Boghosian:

The other members of the 2009 Award Committee for Art were William Bailey, Jennifer Bartlett, Chuck Close, Jane Freilicher, Martin Puryear, Robert Ryman, Ursula von Rydingsvard.

For over fifty years, STEPHEN ANTONAKOS has explored three-dimensional form with electrified neon gas and the wall plane. The intense color of the neon emanating from the forms onto the wall is astonishing.

GREGORY CREWDSON makes worlds. They are places sometimes frightening, sometimes lonely, always in a secret way unbearably beautiful. His photographs are images that carry an eerie familiarity, the visual equivalent of déjà vu, the memory you can't quite remember. They become your dreams and you will never touch them.

JOHN DUBROW, a student of Bay Area figuration, has been honing his own formidable representational style in New York for the past three decades. The monumental, unsentimental painting which he developed in the 1990s in cosmic cityscapes has, more recently, been used to capture lone sitters and pocket parks, by way of his particular abstract prism.

DUNCAN JOHNSON creates sculptures out of hundreds of pieces of wood that speak to the history and character of a previous purpose. Using discarded fragments Duncan employs the rich and varied patinas and worn textures of this abandoned material to create cascades of color on a grand scale.

SUSAN JANE WALP is a painter of small still-lifes that are very beautiful and marvels of sympathetic realization.

Presentation of Arts and Letters Awards in Literature by Allan Gurganus

J. D. McClatchy introduces Allan Gurganus.

Allan Gurganus:

The other members of the 2009 Award Committee for Literature were Kwame Anthony Appiah, Mary Gordon, A. R. Gurney, Philip Levine, Rosanna Warren, Edmund White, and Joy Williams. There are eight Academy Awards in Literature.

Five generations of RILLA ASKEW's family have occupied southeastern Oklahoma. Celebrating this birthright, she has concocted of it her own Faulknerian kingdom. Askew is writing a mythic cycle, novels and stories that unsettle our view of the West's settling. In a continuous fictional mural populated with hardscrabble souls—credible, noble, and flawed—Askew is completing the uncompleted crossing of the plains. Trusting prose that is disciplined, luxuriant, and muscular, she is forging a chronicle as humane as it is elemental.

MICHAEL COLLIER's poems partake generously of the worlds they observe. Rich in detail, unflinching in observation, his poems record the ordinary life of suburban American childhood and adolescence, and equally ordinary grown-up vagaries, in language so gracious it comes as a surprise, time and again, to recognize that he has made us see into the timeless heart of things.

At a time when most playwrights feel lucky if they make it to first base, TRACY LETTS has managed to hit a home run with a prize-winning, full-bodied, three-act study of a Midwestern American family called *August: Osage County*. Both funny and serious, rich with excellent parts for its large cast, the play took shape in Chicago in 2007, opened and is still running on Broadway, was unusually well received at the National Theatre in London, and is now about to tour the country with every promise of continued success.

D. NURKSE writes poems mysteriously spare, unsparing, and elemental. His language seems so simple, one hardly knows how or when the blade of the poem pierces the soul. Under the scab of what we expect to see and to feel, Nurkse discovers paradoxes of love and hostility, of cruelty and innocence, one could hardly have imagined, but which—once seen—feel true, and all too recognizable.

First she mastered the available forms of poetry, and when those failed her—she never failed them—MARIE PONSOT invented her own forms and gave us a poetry like no other. A writer of powerful feelings and razor-sharp wit, she is that totally American phenomenon, the self-invented genius here to tell us who we are and where we aren't. A writer of tough, available, elegant poetry, she has created over the decades her own school of New York poetry.

A dystopian satirist after Gogol's own heart, GEORGE SAUNDERS is a prose master, guiding his wild imaginative flights with perfect control of tone, register, and velocity. His stories and essays display an allergy to cliché and kitsch, and an eye for the higher and lower realms of idiocy, quivering with the laughter

[25]

not of scorn but of painful understanding. For all his postmodern inventiveness, he never allows intellectual gamesmanship to supplant emotional resonance. Saunders doesn't just collect the dead souls of contemporary culture; he brings them back to life.

SUSAN STEWART's mind constitutes a treasure of our age. It is Magellan-fearless while staying Vermeer-intimate. It can go as crystalline and abstract as outer space while retaining the surviving heat of first-person singular. Unlike most academic critics, Susan Stewart explores while in the reader's presence. Her findings assume her reader's shared and equal curiosity. In language blessedly free of fashion-based university double-talk, Stewart's each subject pulls from her some new language it deserves. If Huck Finn was last seen "lighting out for the territories," Susan Stewart has claimed as her territory an informing, descriptive, sort of light itself. Whatever it illuminates, we come to know and see better. Her clarity of enthusiasm has become our atlas.

Presentation of Arts and Letters Awards in Music by Robert Beaser

J. D. McClatchy introduces Robert Beaser.

Robert Beaser:

The other members of the 2009 Award Committee for Music were Martin Bresnick, John Corigliano, Mario Davidovsky, and Shulamit Ran. The four Academy Awards in Music are accompanied by an additional $7500 toward the recording of one work.

DAVID GOMPPER has been creating music for instrumental ensembles of varying configurations and media that captivates listeners and performers with its color, exuberance, and sense of invention. The music is well-proportioned and satisfying, rich in detail, persuasive in its sweep. It is a celebration of music-making that delights the mind and the soul.

DAVID LANG, recent Pulitzer Prize winner, is a composer of a paradoxical sensibility at once wry and passionate. Hovering elegantly between conceptual art and sonically ingenious music, his compositions stutter eloquently as they enact their simple, ambiguous beauty. No one writes music like David Lang; he may be measured only by his own unique achievements. And there are more to come.

ANDREW WAGGONER's voice is distinctively of this country, continuing—or rather, reinventing—something like the Ameri-

can neoclassic vein of Copland, Harris, or Schuman, but making it completely new and completely his own. His passion, fierce and luminous and humane, shines unmistakably from every measure. His boundless energy is infectious. Waggoner's music never stops celebrating, and it never stops striving either.

BARBARA WHITE's music reflects a mind bursting with imagination, curiosity, and a sense of exploration all its own. The sonic impact, a cornucopia of fresh delights, is balanced by immaculate attention to shape and form. Her music is provocative even when it speaks in undertones, creating a personal space that is as unique as it is inviting.

Presentation of Special Awards and Scholarships

J. D. McClatchy introduces Steven Stucky.

Steven Stucky:

In 1928 Roy Lyndon Danks established a residual trust for prizes to encourage young talent in honor of his father Benjamin Hadley Danks. The trust arrived 75 years later at the Academy and now supports an annual prize, in rotation, to a playwright, a writer, and a composer of orchestral works. This year, the seventh annual *BENJAMIN HADLEY DANKS AWARD IN MUSIC* of $20,000 goes to the composer Sean Shepherd.

The music of SEAN SHEPHERD embodies an elegant degree of precision, a knack for vigorous physicality and virtuosity, and a sensual delight in the properties of musical sound. His sense of post-tonal harmony is unusually acute; the notes in his music are "right." In works like his 2005 sextet *Lumens* and his 2008 *Octet,* Shepherd's hard-edged, crystalline clarity is balanced by moments of intimate poetry and frank lyricism.

J. D. McClatchy introduces Lois Dodd.

Lois Dodd:

The *JIMMY ERNST AWARD IN ART* of $5000 is presented to a painter or sculptor whose lifetime contribution to his or her vision has been both consistent and dedicated. This annual award

was established in 1990 by Edith Dallas Ernst in memory of her husband, a member of the Academy. The award for 2009 goes to the painter Charles Cajori.

CHARLES CAJORI is a painter of imagined figures and spaces which seem always to be caught in the act of defining pose and location. His masterful drawing is crucial in orchestrating the tension between figure and shape. Color is never descriptive, working more as a plastic counterpoint to drawing and combining with it to create images pulsating with energy and life. For several decades Cajori has pursued an ineffable ideal. His paintings are resolved but never finished—works of great beauty and distinction.

J. D. McClatchy introduces Paul Muldoon.

Paul Muldoon:

The other members of the 2009 Committee for the *E. M. FORSTER AWARD IN LITERATURE* were Margaret Drabble and Alison Lurie. The distinguished English writer E. M. Forster bequeathed the American publication rights and royalties of his posthumous novel *Maurice* to Christopher Isherwood, who transferred them to the Academy for the establishment of the E. M. Forster Award. This award, now $20,000, is given to a promising young writer from England, Ireland, Scotland, or Wales, for a stay in the United States. This year it is awarded to the English writer Paul Farley.

PAUL FARLEY is one of the most gifted poets to have emerged in the United Kingdom in recent years. Whether he's writing about a train's dramatic entering of a tunnel or real life television or his own dodgy teeth, he manages to combine the hummability of a well-wrought lyric with a wonderfully humane world picture.

J. D. McClatchy:

The *HASSAM, SPEICHER, BETTS, AND SYMONS ART PUR-CHASE PROGRAM* was begun in 1946 through a bequest from the American Impressionist painter Childe Hassam, who left the Academy over 400 of his works with the request that the accumulated income from their sale be used to establish a fund to purchase paintings and works on paper by living artists for donation to museums across the country. Similar bequests were later made by Academy members Eugene Speicher, Louis Betts, and Gardner Symons. Candidates for purchase are nominated and selected by members of the Academy. Since the inauguration of the purchase program, the Academy has spent almost $3 million for the purchase and donation to museums of nearly 1200 works of art.

I now introduce Ursula von Rydinsgvard, who will read the names of the 12 artists whose works were purchased this year.

Ursula von Rydinsgvard:

This year the members of the Purchase Committee chose works by 12 artists. Members of the Academy are not eligible. A number of these artists are seated in the audience, and their works are on display in the exhibition that opens following this ceremony. I would like to ask that each artist stand as I call his or her name.

CHARLES GAINES	BEVERLY MCIVER
ANN GALE	HARRY NAAR
MARK KARNES	DAVID NELSON
JUDY LINN	JIM NUTT
TINE LUNDSFRYD	CELIA REISMAN
CHRIS MARTIN	STEPHEN TALASNIK

J. D. McClatchy introduces Ellen Taaffe Zwilich.

Ellen Taaffe Zwilich:

The *WALTER HINRICHSEN AWARD IN MUSIC*, established in 1984 by the C. F. Peters Corporation, is given for the publication of a work by a gifted composer. Walter Hinrichsen founded the music publishing firm of C. F. Peters in 1948, and was an enthusiastic supporter of contemporary music. This year the award is given to Victoria Bond.

VICTORIA BOND has earned an enviable reputation as a composer, conductor and promoter of American classical music in a variety of venues throughout the world. Her music is full of vitality and drive yet also tempered by a beautiful sense of lyricism. Those traits have resulted in a very personal and recognizable style. She has produced a great number of works in many media ranging from operas and orchestral works to chamber music and songs. After many years as the music director of the Roanoke Symphony Orchestra she now devotes her conducting time to guest appearances all over the world. Her promotion of American music as well as her promotion of works by emerging composers has garnered great praise from the entire field of concert music.

J. D. McClatchy:

Harmony Ives bequeathed to the Academy the royalties of her husband's music, which has enabled us to give 244 awards to composers since 1970. The prizes being given are fellowships to mid-career composers and scholarships to music composition students. Shulamit Ran will present the Charles Ives Fellowships.

Shulamit Ran:

It gives me great pleasure to present the *CHARLES IVES FELLOWSHIPS IN MUSIC* of $15,000 each to two very talented composers:

YU-HUI CHANG delights in weaving together opposing strands—highly differential instrumental colors and lines which often refer to distant cultures. Then she surprises with sudden clarity. In *Lost Threads* this unity is not preservable, in *Perplexing Sorrow* it is provisionally sustainable. It is done succinctly, never a phrase too long.

RAY LUSTIG is writing music charged with intensity and leavened by intelligence. His *Sonata for Violin and Piano* shows the breadth of his vision. In it, a propulsive first movement which is quite shattering is followed by a movement of stillness and simplicity. This superimposition of opposites also applies for his award-winning *Unstuck* for orchestra, which explores past and present and the expectations they imply with surprising results.

J. D. McClatchy introduces Mario Davidovsky.

Mario Davidovsky:

The six *CHARLES IVES SCHOLARSHIPS IN MUSIC* of $5000 each are given to exceptional students for continued study in composition. Will the Ives Scholarship winners please come to the lectern.

MATTHEW BARNSON	DAVID M. GORDON
RYAN GALLAGHER	ANDREW NORMAN
MICHAEL GILBERTSON	CAROLYN O'BRIEN

J. D. McClatchy introduces Kwame Anthony Appiah.

Kwame Anthony Appiah:

The *SUE KAUFMAN PRIZE FOR FIRST FICTION* was established 30 years ago to honor the memory of the writer Sue Kaufman. It is given for the best first novel or collection of short stories published in the preceding year. The $5000 prize goes to Charles Bock for *Beautiful Children.*

CHARLES BOCK's resourceful, calibrated style perfectly renders the chaos of Las Vegas teen culture, all the horror and pathos of runaways consumed by the industries of pornography and drugs and prostitution. Nothing in this fiercely original novel is familiar or consoling; it is so searing it should be printed on asbestos. *Beautiful Children* is an indisputably authentic report from the trenches of how the disenfranchised live now.

J. D. McClatchy:

A self-taught painter, John Koch was born in Toledo, Ohio in 1909, lived his life in New York City, and was elected to the Academy in 1970, 8 years before his death. He was best known as a painter of fashionable Manhattanites who would gather at his elegant apartment facing Central Park West. Both his group studies and his still-lifes reveal the depths he found in the surfaces of things, the secrets in a crowded room—relationships and lusters alike were the subject of his discerning and moral eye. He was a painter in the tradition of Vermeer and Eakins, and an award in his honor pays tribute to a grand tradition as well as to the remarkable artist receiving it. William Bailey will give the John Koch Award in Art.

William Bailey:

In 1989, Dora Koch, widow of Academy member John Koch, left the Academy a bequest to establish an award in art to be given to a young artist of figurative work. This is the inaugural year of the *JOHN KOCH AWARD IN ART*. The $10,000 prize goes to Elisa Jensen.

ELISA JENSEN's paintings of figures in landscape or beside the sea evoke a dim and haunting northern light. Composed simply with startling juxtapositions of shape, her color resonates in a low register punctuated by small areas of focus in brighter color. Her paintings are grand in scale and ambition.

J. D. McClatchy introduces Martin Bresnick.

Martin Bresnick:

The *GODDARD LIEBERSON FELLOWSHIPS IN MUSIC*, endowed in 1978 by the C. B. S. Foundation in memory of Goddard Lieberson, the late president of C. B. S. Records, are given to young composers of exceptional gifts. The fellowships this year of $15,000 each are awarded:

LAURA ELISE SCHWENDINGER's music displays an exquisite sense of timing, imagination, and communicative skill. Her composition, *High Wire Act* for chamber ensemble, possesses a colorful, bright, sonic veneer combined with a lucid and logical compositional exploration of her musical material. The work shimmers and resonates on a number of different levels and reflects the work of a composer who has found her own voice and is rejoicing in that realization.

KURT STALLMANN's work convinces by its range—from ambitious chamber works to demanding multi-media pieces;

works incorporating electronics; experimental improvisations; and collaborative projects with distinguished artists and film-makers. Although the range and medium of expression is broad, there is a stylistic and aesthetic acumen that reveals itself to the attentive listener—a headstrong integrity! His infallible musical ear ensures a consistency in structure from the local to macro levels.

J. D. McClatchy introduces Joy Williams.

Joy Williams:

The *ADDISON M. METCALF AWARD IN LITERATURE* was established in 1986 through a bequest from Addison M. Metcalf, son of the late member Willard L. Metcalf (1858–1925), and honors a young writer of great promise. This biennial award of $10,000 goes to Ron Currie, Jr.

 RON CURRIE, JR.'s slim, nervy first collection of stories, *God is Dead,* is a lively wide and dry-eyed ride into the abyss. Heart and pleasure, if not solace, can be taken from these fresh fictions in which at last, in part, we have been given a talking dog we can believe in.

J. D. McClatchy introduces Stephen Sondheim.

Stephen Sondheim:

Academy member Richard Rodgers endowed these awards to subsidize productions, studio productions, and staged readings, by nonprofit theaters in New York City, of musical works by composers and writers who are not yet established in the field. Since 1980, 16 musicals have received production awards, 6 have been

given studio productions, and 48 have received staged readings. The *RICHARD RODGERS AWARDS* are the Academy's only prizes for which applications are accepted. Playwrights and composers from across the country are invited to enter their original works for the musical theater. The other members of this year's award committee were: Lynn Ahrens, John Guare, Sheldon Harnick, David Ives, Richard Maltby, Jr., and Lin-Manuel Miranda.

This year there are two winners of staged readings: KARLAN JUDD, composer, and GORDON LEARY, playwright and lyricist for the musical, *Cheer Wars*; and SCOTT ETHIER, composer, and JEFF HUGHES, playwright and lyricist, for *Rosa Parks*.

J. D. McClatchy introduces Robert Pinsky.

Robert Pinsky:

Each year since 1951 the Committee for Awards in Literature has selected and partially subsidized a young writer of extraordinary promise for a year's residence at the American Academy in Rome. Since 2001, they have requested that we choose two writers each year to go to Rome. This year, the Committee for Awards in Literature has chosen these two young writers to spend the year in Rome. The winners of this year's *ROME FELLOWSHIPS IN LITERATURE* are Peter Campion and Eliza Griswold.

Because his language is so alive and spicy, PETER CAMPION can write about almost anything and make it memorable. His poems are equally at home in the cities of today and in the wreck we've made of nature. Reading him, you feel the whole weight of American poetry from Whitman through Hart Crane to Kenneth Koch ennobling his lines and giving them both their form and their crackle.

ELIZA GRISWOLD is both a poet and a respected international correspondent. Her gripping war-zone essays have traced humanity's worst behavior alongside its very best. Griswold's poetry, as informed by Nature as by refugee politics, forges a new map of our hard-fought aspirations. She speaks many languages and seeks an arduous peace in all of them. Her best poetry locates the very marrow of our embattled hopes. Eliza Griswold's wise poems bring us a more ancient form of news.

J. D. McClatchy introduces Chuck Close.

Chuck Close:

The Rosenthal Family Foundation Awards in art and literature are among the oldest awards given by the Academy. These awards, established by Richard and Hinda Rosenthal, have encouraged emerging artists and writers. Exactly fifty years ago, the award in art was established, and today, the *ROSENTHAL FAMILY FOUNDATION AWARD IN ART* of $10,000 goes to Hilary Harkness.

HILARY HARKNESS populates her obsessively painted, ravishingly beautiful small paintings with miniature killer lesbians performing various mundane tasks more often stereotypically associated with men. Her work owes as much to Paul Cadmus and George Tooker as to her own contemporaries. In cutaway views into buildings or submarines, we find her scantily clad figures behaving as powerful Barbie dolls from hell.

A. R. Gurney:

Fifty-three years ago, Richard and Hinda Rosenthal established an award in literature to recognize a promising young writer of

fiction for a work of considerable achievement published in the preceding year. Richard and Hinda have passed away but the Rosenthal family, five of whom are sitting in the audience today, generously continue these awards.

The *ROSENTHAL FAMILY FOUNDATION AWARD IN LITERATURE* of $10,000 goes to CHRIS ADRIAN,* for *A Better Angel.* Chris Adrian, a medical doctor, sees the world symptomatically, then diagnostically. His language can offer either a curing balm or an emetic, as his story's health requires. Underscoring Adrian's fiction, we're guaranteed what Isaac Babel simply called "an interest in life." If Adrian's fables often begin as bodily emergencies, most feature second and third acts. Chris Adrian's ER appetite for disaster is abetted by his gift for honest redemption, permanent healing. Here is a voice as sane as it is joyful.

J. D. McClatchy introduces Janet Malcolm.

Janet Malcolm:

The *HAROLD D. VURSELL MEMORIAL AWARD* of $10,000 was established in 1979 to single out recent writing in book form that merits recognition for the quality of its prose style. Harold Vursell was vice-president and managing editor of Farrar, Straus & Giroux. The award this year goes to the writer Sharon Cameron.

SHARON CAMERON's grave, lithe intellect ushers the attentive reader into the fulsome, light-filled caves beyond comprehension. A challenging yet immensely rewarding writer, her essays and meditations on being and literature are enigmatic, subtle, and exhilarating. Scholar and seeker, her quest for the divine undifferentia makes her, paradoxically, a great original.

*Not present.

J. D. McClatchy:

One of the members sitting on stage at the first public ceremonial in 1941 was Thornton Wilder, who had been elected to the Academy in 1928, at the age of 31, the same year he won the first of his three Pulitzer Prizes, this one for *The Bridge of San Luis Rey*. We know Wilder best as a playwright and a novelist, but all his life he pursued his passion for the literature of other languages, and was a master of several. In 1949, for instance, at the Aspen Institute where Goethe's bicentennial was being celebrated, he spontaneously translated speeches by Albert Schweitzer and Jose Ortega y Gasset. He taught French literature at Lawrenceville, he translated plays by Ibsen and Sartre, he catalogued the plays of Lope de Vega, he knew Austrian farce inside out. "Literature," he once wrote, "has always more resembled a torch race than a furious dispute among heirs." And his own example of sympathy and generosity, his fascination with the idea of "world literature," is the spirit behind our next award. Will Edward Albee please come forward to present the Thornton Wilder Prize for Translation?

Edward Albee:

To honor Wilder's enthusiasm for the art of translation, his sense that the human imagination needs all the world's riches as its store, his nephew and niece, Tappan Wilder and Catherine Guiles Wilder, have established the *THORNTON WILDER PRIZE FOR TRANSLATION* of $20,000 to a practitioner, scholar, or patron who has made a significant contribution to the art of literary translation. This is the inaugural year of the award. It is my pleasure to present this award to the translator Gregory Rabassa.

 GREGORY RABASSA has brought the art of translation to a

new eminence. No better proof of that could exist than Gabriel García Márquez's often-cited preference for Rabassa's version of *One Hundred Years of Solitude* to his own Spanish original. Rabassa has brought over into English many of the titans of South American fiction in translations that are both scrupulous and inventive, and in doing so he has created a luminous ideal to which all translators now aspire. He has mastered the magic of conjuring from a thousand possibilities the single best choice. That is one definition of a classic.

The Blashfield Address

J. D. McClatchy:

THE HIGHLIGHT of each year's ceremonial is the Evangeline Wilbour Blashfield Foundation Address, endowed in 1916 by Mrs. Blashfield, and delivered over the years by such formidable lions as Elizabeth Bowen, Aaron Copland, Nadine Gordimer, Mario Vargas Llosa, Robertson Davies, George F. Kennan, and Iris Murdoch. Today is the 80th occasion the Blashfield Address has been given, but only the eighth time it has been given by a poet. Mind you, the likes of Robert Frost, Robert Graves, and Octavio Paz were among the earlier seven.

And today I am pleased to introduce one of this country's most distinguished poets, Louise Glück. Her eleventh collection of poems is soon to be published, and her books have won the Pulitzer, Bollingen, and National Book Critics Circle prizes. She has served as the United States poet laureate, and teaches at Yale. But beyond the honors, of course, is the art—a stern and stunning art of rare beauty and force. Her work asks the difficult questions, and seeks out its answers with a dark, exalted imagination, a gravity of phrasing and unearthly tone.

This afternoon, her subject is something that has, for a couple of centuries now, been taken for granted or argued over, used to justify ends both high and low, and is hardly ever understood. I'm speaking of the idea of American Originality. Ladies and gentlemen, please join me in welcoming Louise Glück.

American Originality
by Louise Glück

W E A R E , famously, a nation of escaped convicts, younger sons, persecuted minorities and opportunists. The fame is local and racial: white America's myth of itself. It does not, obviously, describe Native Americans and African-Americans: though they are theoretically free to participate in mythic America's notions of vigor and self-creation, to do so involves sustained acts of betrayal or disloyalty toward origins they had probably no communal wish to escape. Oppression, for these groups, did not define the past; it replaced the past, which was transformed into a magnet for longing.

The myth elaborates itself in images and narratives of self-invention—drive and daring and gain being prized over stamina and fortitude. If the Englishman imagined himself as heir to a great tradition, the American imagined himself as the founding father. This difference resonates in political rhetoric: American aggressive might (usually called defense) and acquisitiveness (sometimes called co-development) as opposed, say, to the language of appeal which links Churchill to Henry V, a language that suggests that the Englishman need only manifest the virtues of his tradition to prevail. These appeals were particularly powerful in times of war, the occasions on which the usually excluded lower classes were invited to participate in traditions founded on their exclusion.

Like most myths, this one has some basis in fact. There were such flights. And immigrant populations whose relocations are,

in the main, escapes from incarceration, confinement, danger, or exclusion will hardly cultivate stoic endurance over initiative. The cardinal virtues of this new world depended on repudiations, the cutting of ties, and on invention and assertion. But the imperatives of self-creation cannot be expected to bind a society as effectively as does the invoking of a shared tradition. The best that can be said is that these imperatives may constitute a shared ambition or common practice; in fact, they are the opposite of coherence. Individual distinction expresses itself as distinction from the past, from the previously acknowledged limits of the possible, and, as well, from contemporaries. Still, the triumphs of self creation require confirmation, corroboration. They postulate (at least imaginatively) a society or audience coherent enough to recognize and reward the new. The new thing makes a kind of adhesive, gluing together (provisionally) its diverse precursors in a grid or system: a fantasy or projection of common values. How this occurs, and with what restrictions, accounts for the peculiar attributes of what Americans call originality, their term of highest praise.

Original work, in our literature, must seem somehow to break trails, to found dynasties. That is, it has to be capable of replication. What we call original must serve as a model or a template, binding the future into coherence and, simultaneously, though less crucially, affirming the coherence of the outstripped past. It does not so much reject tradition as project it into the future, with the self as the progenitor. Originality, the imprint of the invented self, depends on the creation of repeatable effects. Meanwhile, much that is profoundly original but unlikely, for a variety of reasons, to sponsor broad imitation, gets overlooked, or called that lesser thing, unique—valuable, undoubtedly, but a dead end. The original is sought with famished intensity; all

the brilliant banners of praise are deployed to welcome it. But to welcome it within certain limits, with formal innovation of almost any kind valued over idiosyncratic mind.

This isn't to say other gifts attract no admiration. Technical mastery continues to be applauded, though chiefly in those born elsewhere. An American Heaney would not, I think, be so promptly and passionately acknowledged. Likewise Szymborska, whose art (in translation) appears a brilliant example of inimitable intelligence. Something, whether atavistic longing or helpless recognition, keeps them, and a few others, safe here.

Americans fare less well. Particularly the unique, the inimitable.

The dark side of self-creation is its underlying and abiding sense of fraud. A reciprocal terror of deficit within the self may account for the American audience's readiness to be talked down to, to be excluded, to call great art that which it does not understand. As American poets increasingly position themselves against logic and observation, the American audience (often an audience of other writers) poignantly acquiesces.

Under the brazen "I made up a self" of the American myth, the sinister *sotto voce*, "I am a lie." And the liar wishes to elude: to elude judgment and censure, to avoid being caught. The literary art of our time mirrors the invented man's anxiety; it also affirms it. "You are a fraud," it seems to say, "You don't even know how to read." And for writers, this curious incomprehension, this being ahead of the time, linked as it is to affirmation, seems superficially encouraging, as though "to understand" meant "to exhaust."

Limitless, untethered freedom has, among its costs, a kind of paranoia: the self not built from the inside, accumulating in the manner of the tree, but rather postulated or improvised, moving backward and forward at the same time—this self is curiously

unstable, insecure. When imagination is immense (as in the case of genius or mania) the nagging sense of falsehood probably dissolves. When it is not, the weak place is fiercely defended.

Part of that defense is the conviction that everyone else is equally inauthentic. Or, alternatively, to locate authenticity (the truth of a historical moment) in the inscrutable. Individual, irreplaceable human voice is doubly disadvantaged. It cannot, as formal invention or trick, be imitated, perpetuated. Second, insofar as it relentlessly manifests a particular human voice neither intellectually constructed nor devised, reactive to a world dangerously like the world we inhabit, it implicitly reproaches invention's willed strategies and poses.

Central to America's myth of itself is the image of a better world, a translation of theological vision to the pragmatic and earthly. This idea is not unique to American democracy, nor has the failure—or at least naiveté—of its many iterations obliged a reexamination of the underlying premise. In our period these various stabs at a better world share a set of promises to the individual, whose life is to be relieved of oppression; what varies is the precise definition of oppression. But the idea of individual independence—the possibility held out that anyone can rise to prominence or wealth or glory—this dream of individual distinction has become a defining attribute of democracy. It seems sometimes that as democracy appears more flawed this promise of an unprecedented self grows more fervent, more necessary.

But the self-made man, like any figure of power, depends on a broad accord; his peers must acquiesce to his accomplishment. In a period in which the future has come to seem a hopeful theory rather than a certain fact, this stake in the present has intensified. The qualities we continue to prize, immediacy and scale, must be manifest immediately. Critical hyperbole confirms this

pressure, it does not create it. Our culture and our period combine to support the American archetype: the artist must look like a renegade and at the same time produce an aesthetic commodity, a set of gestures instantly apprehended as new and also capable of replication.

The cost of this pressure has been immense, both to the neglected (in whom it fosters a bruised independence that too easily becomes entrenched rigidity) and to the admired, who, like Lowell in the recent past, sense their real discoveries diluted by immediate and often canny imitation. To tell the original from the copy becomes increasingly difficult. Gradually, through this process, the bold new artist is revealed to have limitations. Likewise the new world persistently fails to sustain itself, and the known world reconfigures itself through a variety of cultural and historical changes. None of this has any impact on the vigor of the myth.

I think the reverse is true. Like all myths of the possible, the compensatory fantasy that one can make a new self survives not despite but because of its failures. For artists, because it appeals to imagination, it has great durability and great utility. It feeds hope: that it has failed in the past leaves room for oneself and one's genius.

Presentation to Juhani Pallasmaa
of the Arnold W. Brunner Memorial
Prize in Architecture by Steven Holl

In 1955 a bequest from Emma Beatrice Brunner, widow of Academy member Arnold W. Brunner, established an annual prize to an architect from any country who has made a significant contribution to architecture as an art. The 2009 award of $5000 goes to the Finnish architect JUHANI PALLASMAA. The citation reads:

> Beyond being a great teacher and a brilliant architect, Juhani Pallasmaa has written passionately and poetically about architecture. In books like *The Eyes of the Skin* his arguments connect us to the deepest issues penetrating to core meanings.

Presentation to Denis Johnson
of the Award of Merit Medal for the Novel
by Russell Banks

J. D. McClatchy:

Since 1942 the Academy has given the Award of Merit Medal to an outstanding practitioner of one of the following arts, in rotation: Painting, the Short Story, Sculpture, the Novel, Poetry, and Drama. The first to win the award for the novel was Theodore Dreiser in 1944, and since then it has been given to Thomas Mann, Ernest Hemingway, Aldous Huxley, John O'Hara, Vladimir Nabokov, and only six others. Russell Banks will present this year's medal for the novel.

Russell Banks:

I am pleased to report that the committee for awards in literature has selected a most talented writer to receive the Award of Merit for the Novel. This award consists of a medal, designed by Academician Herbert Adams, and is accompanied by a check for $10,000. The 2009 Award of Merit Medal for the Novel goes to DENIS JOHNSON. His citation reads:

> Denis Johnson plunges directly into the boiling crucible of consciousness, but the finesse and delicacy with which he observes and writes are equal to its potentially annihilating chaos; Johnson can render into words the most inchoate, evanescent,

and anarchic sensations and impulses. His dialogue is terrify-ingly funny, terrifyingly natural—and he illuminates with great tenderness the inviolable humanity at the core of each of the characters who wander, lost, through the violent and stricken landscape of his pages.

Presentation to Suzanne Farrell
of the Award for Distinguished Service
to the Arts by Edmund White

J. D. McClatchy:

The Award for Distinguished Service to the Arts is one of our most cherished honors, and since 1941 has been bestowed on some extraordinary, and extraordinarily creative people, from Robert Moses, Walker Evans, and Leopold Stokowski, to Beverly Sills, James Levine, and Michael Bloomberg. From the world of dance, among previous recipients of this award are Martha Graham, George Balanchine, Jacques d'Amboise, and Arthur Mitchell. This year the award is being given to Suzanne Farrell.

I remember watching her dance, night after night in the old days, and thinking in the end that at last I understood what it meant when a character in Homer saw a goddess appear suddenly before him—a figure at once regal and vulnerable, commanding and heart-breaking, luminous and life-changing. She gave us memories like none other. But she took her own memories and made them first into a company, the Suzanne Farrell Ballet, resident at the Kennedy Center, and then the Balanchine Preservation Initiative Trust. She was Balanchine's muse and greatest dancer, and now has taken his legacy—his vision and virtuosity—and kept it a living art, the embodiment of human movement in an eternal time and space. We honor her today for her sublime artistry, for her courage, and for her leadership. To present the award is the novelist Edmund White.

Edmund White:

During the years Suzanne Farrell reigned as America's great-
est ballerina, some of her critics complained that she seemed
reserved and even cold, but her fellow dancer Diana Adams de-
fended her brilliantly by saying, "she withholds nothing physi-
cally from her dancing, and what she seems to withhold person-
ally isn't the absence of anything so much as it is the presence
of a personal mystery." Anyone who has seen her in recent years
work with dancers as a choreographer and as the director of
her own company knows that she is able to make each perform-
er look better than ever before. She is giving everything to the
young people who come to work with her. The only mystery she
retains is the glowing, shimmering mystery at the heart of all
art, and of Balanchine's art in particular. As a ballerina she was
known as both the greatest of adagio dancers and as one of the
fastest, and seemingly most reckless, speed-demons on the stage.
This versatility she now bestows on her company and students.
She also introduces them to the pulse, the asymmetry, the el-
egant athleticism and the bewildering variety of the Balanchine
repertory. So many of the great ballets of the 20th century were
created for her; now she re-creates them for the young in the
21st century. In the '70s, she and her partner Peter Martins were
known to their fans as "Mr. and Mrs. God." Now she is a different
kind of goddess, no longer a muse but a tutelary deity. When an-
other dancer once asked why Balanchine created so many works
for Farrell, he said, "Well, you see, dear, Suzanne never resisted."
I am happy to read the official citation from the Academy to this
irresistible artist.

Suzanne Farrell remains one of America's greatest artists in dance. As a dancer with the New York City Ballet and later, as an artistic director of The Suzanne Farrell Ballet, she honored and kept Balanchine's work alive. She dwelled in its spirit: she was its spirit for a time. It is that spirit, as well as Balanchine's vision and legacy, that Farrell has understood and perpetuated for generations of dancers and audiences.

ACCEPTANCE BY SUZANNE FARRELL

Thank you. It's an honor to share this ceremony with such an esteemed group of people.

Ballet is a young art compared to music, opera, or theater. A score, a piece of music will always be as the composer intended; the notes will never change. Words are written down, and become the text of a great poem, or play. But choreography is subjected to many variables, and as dancers, we are our own technology, our only instrument. There is no cinematographer, no editor, no soundtrack to enhance us; and, as such, it is very fragile, which makes us strong. It has been said that the life of a true artist, like true love, is a matter of paying the closest attention possible as we strive to unite the perfection of craft with the complex understanding of its personal and profound significance.

Thank you very much.

Presentation to Leon Kirchner
of the Gold Medal for Music
by Samuel Adler

J. D. McClatchy:

Every year since 1909, the Academy has given Gold Medals for distinguished achievement in the fields of Belles Lettres and Criticism, Painting, Biography, Music, Fiction, Sculpture, History, Architecture, Poetry, Drama, and Graphic Art. The medals are given in rotation among these disciplines for the entire work of the recipient, and are voted on by the entire Academy membership. This year, we are presenting two Gold Medals: for Music and for Poetry.

The first Gold Medal in Music was awarded in 1919 to Charles Loeffler, and in those early years it was given to, among others, Igor Stravinsky and Aaron Copland; later to Elliott Carter, Samuel Barber, and Leonard Bernstein, Hugo Weisgall, Lukas Foss, Ned Rorem, and Stephen Sondheim. It is my pleasure to introduce Samuel Adler who will present this year's Gold Medal for Music.

Samuel Adler:

It is an honor and a privilege for me on the part of the Academy to present this year's Gold Medal for Music to an extraordinary composer who has written hundreds of works of great vitality, originality, and superb musicality throughout his long

career. Works that have been called "a tribute to music's capacity to astonish and enthrall." From chamber music to large orchestral works and opera, he has reached the heights of excellence, and, on the way, has been awarded some of the most prestigious honors, including the New York Music Critics Award in 1950 and 1960 and the Pulitzer Prize in 1967 for his *Third String Quartet*. Through the years he has taught, mentored, and inspired hundreds of young composers, especially during his many years at Harvard University. Further, he has maintained a busy performance schedule as a pianist and conductor of both the contemporary as well as the standard repertory.

The Academy and all its members congratulate Leon Kirchner and are proud to present to him the 2009 Gold Medal for Music with a sincere wish for many more healthy and creative years. The citation reads:

> Leon Kirchner writes beautifully imaginative, colorful, and perfectly constructed music with delicate lines and subtle rhythms. It is powerful at times, but can be also gentle and meditative. His orchestration is distinct and imaginative, and his chamber works exquisitely sophisticated and virtuosically crafted. His music is delicate, poetic, and always original, as well as of great insight. Leon Kirchner is a unique composer-artist, an American Master.

Thank you, Sam. You are most gracious.

On March 30, I received a beautiful and dazzlingly eloquent letter from J. D. McClatchy: "You have been enthusiastically chosen to receive the Gold Medal of the Academy…our highest award, etc., etc." I shall not forget this letter, for which I am profoundly grateful, nor the trust and generosity of the Academy. Stunned, for not only were the two other candidates proposed by the Music Committee very strong candidates, but on reading the names of previous awardees—Stravinsky, 1951; Copland, 1956; and Sessions, 1961, I found it difficult to respond. However, with the letter came a bag with a bottle of champagne within. My dear friend Sally Wardwell shot the cork and out came exquisite champagne, so exquisite in fact that we finished the bottle in a single sitting. By then I was ready to accept this or any other dream-like event.

Lucky in my teachers and mentors, I was a student of Arnold Schoenberg at UCLA, Ernest Bloch and Roger Sessions at Berkeley. They were profound teachers of the art of music and its technique and structural diversities. I learned as much as I was able to digest at the time. Years later, I understood the rest. My mentors were Aaron Copland at Tanglewood and New York and Igor Stravinsky, whom I met later in the early '50s after returning from the East Coast. Both were enormously helpful— Copland for the first writing about my music and arranging the world premier of my first quartet by the Juilliard Quartet for the League of Composers, and Stravinsky for obtaining for me the Luther Brusie Marchant Chair at Mills College. I was its first occupant. By then I had completed my *Piano Sonata,* my *Duo No. 1,* and my first String Quartet.

One day I received a phone call. "This is Igor Stravinsky. I would like to invite you and your wife to dinner and become more acquainted with you and your work." Amazed, I answered, or thought I did, "This is Fyodor Dostoevsky. I accept with pleasure." But it really was Igor Stravinsky and for us it was an astonishing evening.

My wife and I invited Stravinsky to dinner some weeks later and he arrived with a satchel containing four bottles of wine, which he shared with us during dinner. That evening I played for him my *Sonata Concertante* for piano and violin, which I was working on at the time. After I played the last movement he said that this, the last movement, was the direction I should be taking. Earlier, I had played the same work for my teacher, Roger Sessions. He said that it was the opening movement that held great promise. Both were correct.

The Archivist of the Academy had asked for a one-page summary of the reach and thrust of my composition, a daunting task. Fortunately, I had come upon an article in the *New York Times* written by the then Poet Laureate, 1996-1997, and, as I now know, a fellow awardee of the Gold Medal of the Academy. He wrote, "Each poem must, to a certain extent, speak for itself, for its own newness, show its ties to the conventions of the moment and its distortions of them. It must make us believe that it belongs to our time even though what it tells us is really old.... This is the secret life of poetry. It is always paying homage to the past, expending a tradition into the present." This statement could well stand for the reach and thrust of my own compositional work.

Thank you, Mark Strand, for your deep, succinct, and apt comments concerning the contemporaneous. Thank you, stu-

dents, both composers and performers, whom I taught during my over half century of teaching. I learned much from you as well. Thank you, all.

I must now stop, "for I have promises to keep and miles to go before I sleep."

Presentation to Mark Strand
of the Gold Medal for Poetry
by Rosanna Warren

J. D. McClatchy:

This is the 14th time since 1909 that the Gold Medal for Poetry has been bestowed, and among its previous recipients were Edwin Arlington Robinson, Robert Frost, Marianne Moore, William Carlos Williams, W. H. Auden, and Richard Wilbur. It is my pleasure to introduce Rosanna Warren—whose father, Robert Penn Warren, himself won the Gold Medal in 1985. She will present this year's Gold Medal for Poetry.

Rosanna Warren:

The members of the Academy, in their wisdom, give the Gold Medal for Poetry to Mark Strand. He is a true, not a false, original. Over and over he has re-invented the lyric poem. His poems have created a new inner space for the imagination, and furnished that space, and invited us in. He has taught us how to dream. Here is the citation:

> Mark Strand gave a new and distinctive sound to American poetry with his mysterious early books. Those poems presented metaphysical conundrums; eerie narratives in spectral landscapes; and speakers who specialized in vanishing. But in the last twenty years, Strand has outpaced his earlier successes, and

experimented with fuller cadences in poems that combine lushness, longing for the sublime, and ironic restraint. His poems have become, in oblique ways, both Dantesque and Orphic. He is also darkly funny. He has evolved a sophisticated and original form of American Romanticism, grafting Kafka onto Wallace Stevens to produce an oeuvre that is his alone.

ACCEPTANCE BY MARK STRAND

I have always, in my own work, favored simplicity and directness in the shaping of imagined sound into utterance. I have tried to fix in language what is most elusive, to locate the ghost within each experience so that it might be seen or felt and finally acknowledged as a kind of truth. And in offering my thanks to the members of the Academy for having voted to award me the Gold Medal for Poetry, I cannot help but be direct. I am humbled when I think of those who have received it before me, whose work I have revered throughout my writing life. To be the latest addition to a list that includes Robert Frost, Marianne Moore, W. H. Auden, Robert Penn Warren, and, more recently, Richard Wilbur, John Ashbery, and W. S. Merwin is an exceptional honor. I have always considered it a privilege to be a member of this great institution whose primary and praiseworthy mission is to further the cause of the arts by recognizing and rewarding talent. And now I feel doubly privileged in having been chosen to receive this award. Thank you, members of the Academy. Thank you.

ORGAN

J. D. McClatchy:

THANK YOU for coming here today to help us celebrate the achievements of these talented artists. There is a famous old story that Cimabue was struck with admiration when he saw the young shepherd Giotto sketching sheep. But it was not sheep that inspired Giotto with a love of painting. Rather, it was his first sight of the paintings of such an artist as Cimabue. The people we have honored today, and wish to honor in the future, are individuals who, in their youth, were more deeply moved by the sight of works of art than by that of the things they portray. They are individuals who have given their lives to what they do—obscurely, grandly, passionately—so that we may all see the world, and ourselves in it, differently.

Well, a man may be absolved for committing murder, but not for delaying a cocktail party. We invite all of you to join us for a reception on the terrace and the opening of the *Exhibition of Work by Newly Elected Members and Recipients of Honors and Awards*. You can easily reach the terrace and the galleries by exiting through the lobby, walking right to Broadway, and turning right again after a few steps, into the terrace. For those of you using the narrow staircase backstage, please remain seated while those on the stage and in the first ten rows of the auditorium exit, in order to avoid a crush on the stairs. Thank you for being with us today, thank you for your patience, and good evening.

T. Coraghessan Boyle, writer

Jorie Graham, writer

Stephen Hartke, composer

Yusef Komunyakaa, writer

Judy Pfaff, artist

Richard Price, writer

Frederic Rzewski, composer

Augusta Read Thomas, composer

Tod Williams, architect

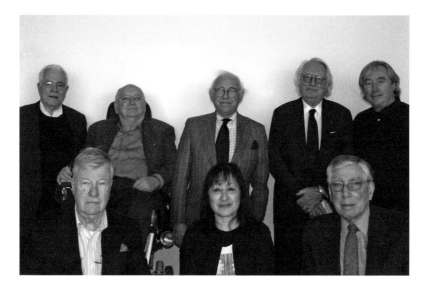

2009 ARCHITECTURE AWARDS COMMITTEE

BACK ROW Peter Eisenman, Michael Graves, James Polshek,
Richard Meier, Steven Holl
FRONT ROW Henry N. Cobb, Billie Tsien, Hugh Hardy

RIGHT SIDE OF PHOTOGRAPH
Open flap on right

l to r

SIXTH (TOP) ROW Juhani Pallasmaa, Shulamit Ran, Frederic Rzewski, Martin Bresnick, David Lang, Laura Elise Schwendinger, Kurt Stallmann, Victoria Bond, David Del Tredici, John Harbison, Jack Beeson, Christopher Rouse

FIFTH ROW Ryan Gallagher, Mario Davidovsky, Samuel Adler, Stephen Hartke, David Gompper, Gunther Schuller, Sean Shepherd, T. J. Anderson, Ray Lustig, Yu-Hui Chang, Yehudi Wyner

FOURTH ROW Michael Gilbertson, Robert Beaser, Steven Stucky, Augusta Read Thomas, Andrew Waggoner, Barbara White, Bernard Rands, Lanford Wilson, Edward Hoagland, Philip Levine, Renata Adler

THIRD ROW Andrew Norman, Edmund White, Susan Stewart, Yusef Komunyakaa, Marie Ponsot, Denis Johnson, D. Nurkse, Charles Simic, Richard Wilbur, Richard Artschwager

SECOND ROW Jeff Hughes, Kwame Anthony Appiah, Charles Bock, Allan Gurganus, Peter Campion, Jorie Graham, Eliza Griswold, Charles Cajori, Philip Pearlstein, David Levine, E. L. Doctorow, Cynthia Ozick

FRONT ROW Karlan Judd, Rosanna Warren, Louise Glück, Robert Pinsky, Chuck Close, Mark Strand, Reynolds Price, Gregory Rabassa, Edward Albee, Leon Kirchner

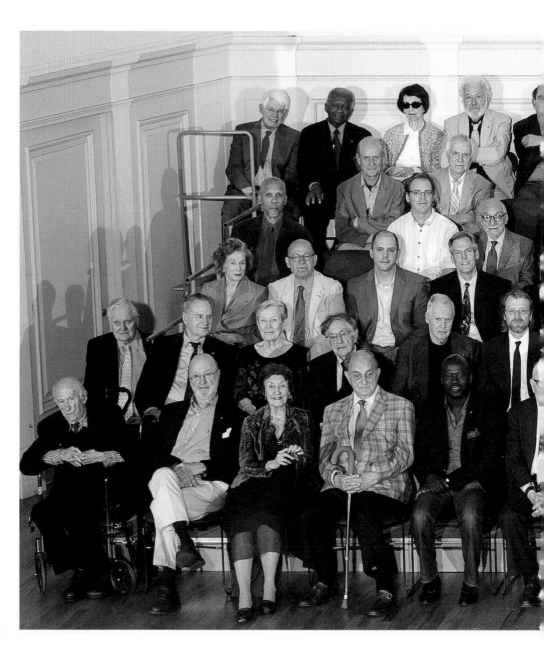

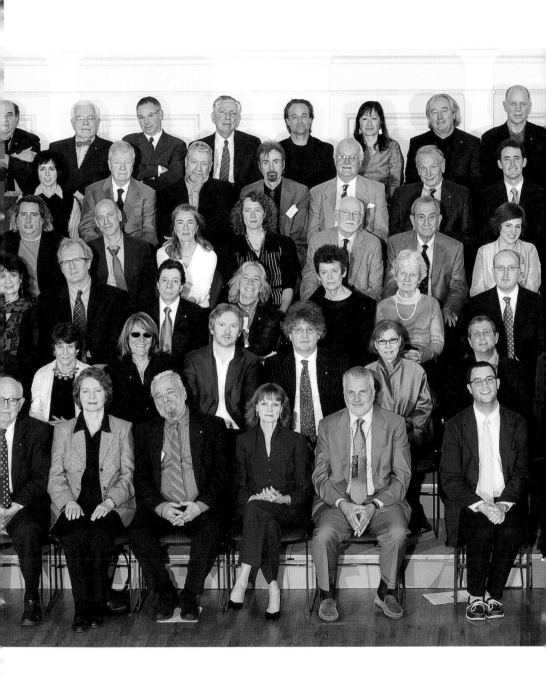

2009 ART AWARDS COMMITTEE

STANDING Robert Ryman, William Bailey, Varujan Boghosian,
Ursula von Rydingsvard, Martin Puryear
SEATED Jane Freilicher, Jennifer Bartlett

Photographs by Benjamin Dimmitt

2009 LITERATURE AWARDS COMMITTEE

STANDING Kwame Anthony Appiah, Philip Levine, Allan Gurganus,
A. R. Gurney
SEATED Rosanna Warren, Joy Williams, Mary Gordon

HORTENSE CALISHER

1911–2009

BY RICHARD HOWARD

When she died at 97 last January, Hortense Calisher had had a couple of marriages and a couple of children, had traveled, as they say, extensively (indeed she married Curtis Harnack in Greece, of which nuptials more later), and had written about 24 novels (including at least one under what we frivolously call a pen name), as well as a collection of all her short stories, another of all her novellas, and several works brilliantly if not clearly autobiographical. She had served as president of American PEN and, of course, of this Academy, on ulterior meetings of which I miss her fiercely, as I do on the occasions of my own life, which she had illuminated and embellished since 1962, causing a certain distress only in those instances when she described, to me, her abundant poetry as "never to be shown."

I deliberately blur the number of Hortense's novels ("about two dozen") because she does so herself, experimenting with notions of genre as severely as she does with those of character and plot and even her own identity therein and . . . therefrom. As she says of what she did and does: "in so much of my life, the saying is the act. In varying shades of distinctness, it is my public life. No matter how private it seems."

In any and all of these doings of Calisher's, the saying is immensely complex, rich in grammatical demands as well as

Read at the Academy Dinner Meeting, April 7, 2009.

PART TWO

Commemorative Tributes

2009 MUSIC AWARDS COMMITTEE

STANDING Robert Beaser, John Corigliano, Martin Bresnick
SEATED Shulamit Ran, Mario Davidovsky

2009 RICHARD RODGERS AWARDS COMMITTEE

David Ives, Sheldon Harnick, Stephen Sondheim, Lynn Ahrens,
Lin-Manuel Miranda, Richard Maltby, Jr.

Photographs by Benjamin Dimmitt

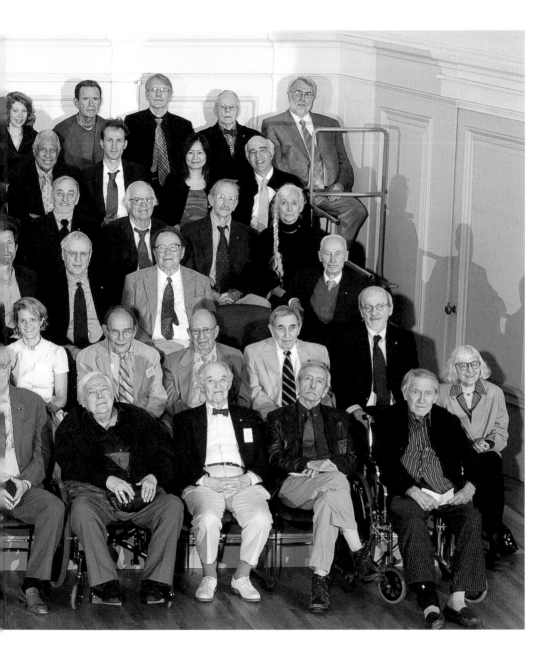

Ceremonial, May 20, 2009
Members and Award Winners on Stage

Open flap on right

l to r

SIXTH (TOP) ROW Wolf Kahn, Richard Hunt, Jane Freilicher,
Paul Resika, Joel Shapiro, Peter Eisenman, Stan Allen, Hugh Hardy,
Wendell Burnette, Billie Tsien, Steven Holl, Tod Williams

FIFTH ROW Rackstraw Downes, Lennart Anderson, Hilary Harkness,
Henry N. Cobb, Jeffrey Kipnis, T. C. Boyle, Russell Banks, A. R. Gurney,
Matthew Barnson

FOURTH ROW Martin Puryear, Duncan Johnson, Stephen Antonakos,
Gregory Crewdson, John Dubrow, Susan Jane Walp, Elisa Jensen,
William Bailey, Varujan Boghosian, Carolyn O'Brien

THIRD ROW Elizabeth Spencer, Richard Howard, Ron Currie, Jr.,
Michael Collier, Rilla Askew, Tracy Letts, Richard Price, Judy Pfaff,
Ursula von Rydingsvard, Lois Dodd, David Gordon

SECOND ROW John Ashbery, Romulus Linney, Paula Fox,
Donald Keene, Ned Rorem, George Saunders, Sharon Cameron,
Joy Williams, Paul Farley, Paul Muldoon, Janet Malcolm, Scott Ethier

FRONT ROW Will Barnet, Jules Feiffer, Shirley Hazzard, Louis Auchincloss,
David Adjaye, Ezra Laderman, Ellen Taaffe Zwilich, Stephen Sondheim,
Suzanne Farrell, J. D. McClatchy, Gordon Leary

Photograph by J. Henry Fair

thematic consistency (it has been remarked how much of her writing is concerned with the Journey, the Voyage, the Transfer, the Movement, the Change), and in this wealth of itinerant conception and execution, this grandest of our living novelists, until last January, was altogether willing only to differ: she was a different novelist, as she was, certainly, a different woman, eager to insist that, as André Gide wailed to his mother after a bad day at the playground, *je ne suis pas comme les autres.*

How different is what Calisher is concerned, is obsessed to tell, and her enormous oeuvre clarifies the unlikelihood, the contrariety, the opposition. At the memorial for Hortense, Curtis told an illustrative story I am compelled to repeat: they decided—each had been traveling in exotic places, Hortense in Pakistan, Curtis in what was then often referred to, still, as Persia—to marry one another in Greece, God knows why, and after much poking around they found a Presbyterian minister in Athens who would perform. This man of the cloth, however, upon discovering that the couple before him consisted of two writers, found it necessary to compose, on the spot, a little homily about the duty of spiritual meditation ("just a few moments, a few lines a day") as a guide to a happy connubial existence. Whereupon Hortense broke in upon the minister's lucubration: "I don't believe you understand what it is we do. When you urge upon us spiritual meditation, I think you fail to realize . . ." at which point Curtis told us that he elbowed his bride-to-be rather fiercely and whispered, "Honey, shut up, or he's not going to marry us."

It was Curtis who retailed this instructive episode, not Hortense who wrote it. But differences seem to be implicit even at the outset of one of the most interesting unions I have ever had occasion, over many lustra, to observe. I prefer to end with a revealing anecdote of my own, but first I want to commend

to your attention three of Hortense Calisher's finest works: her first novel, *False Entry*, published when she was 50; *Mysteries of Motion* published in 1983; and from 1997 *The Novellas of Hortense Calisher*.

Now for my telling intimerie: as I suspect I have indicated, there was a lot that was sibylline about Hortense, and not only in her works; I frequently needed the sibyl's advice, and back in 1992 I was especially needy because my editor, not a notably homophobic man, had just told me that one of the most ambitious of my new poems "would not do," and I came sniveling to my private sibyl, who "comforted" me thus:

I do not see why or on what this poem should be objected to. One can hazard a guess, though rather foolishly, and without any knowledge of the objector: Is taking inspiration from a newspaper account a "low" thing to do, too literal, etc. Should such a subject be treated only in "high" poetic style? whatever that is. (I leave the current clichés about "high" and "low" to the curators at MoMA.) You've certainly written knottier, less immediately accessible poetry—is that where the line should be drawn, on sexual material? Not for me—nor is any subject inherently "cheap" or sensation-seeking—indeed this poem is the obverse of that. The woman's voice is at first markedly simple and humdrum, but as the vernacular often is. The other part of the dialogue utterly redeems that, taking flight from it. Finally: were you being asked to move on from the subject altogether?—in ordinary times the equivalent would be "Can't you stop talking about Death?" Maybe it was none of that, but the climax of whatever else was simmering in a long relationship?

So much for sibylline comfort. To conclude: what is best said, in tribute, is merely—merely!—that Hortense Calisher is a great figure in American fiction, indeed in American writing of the late twentieth century, and if I were to be sibylline myself, I should apply that description of the author to the woman herself, a great American figure.

NORMAN DELLO JOIO

1913-2008

BY DAVID DEL TREDICI

Norman Dello Joio was well-named—*gioia* being the Italian word for joy!—and certainly Norman, with his many exuberant compositions, brought much joyful music into our world.

His work was widely celebrated with honors galore: a Pulitzer Prize, two New York Critics Circle Awards, and an Emmy—to mention but a few.

Norman's musical output was extraordinary—much performed and well-documented in recordings. I learned this acutely well, typically finding his name right before my own in record catalogues and in LP/CD bins (back when there were record stores!).

It was extraordinary, too, that in each year from 1940 to 1984—without missing a one—Norman Dello Joio wrote two, three, or four significant works. His skill extended to all genres with equal effectiveness. But it was perhaps the human voice that inspired him most—especially the massing together of voices. In his catalogue, choral works abound, whether for unaccompanied chorus or for chorus with orchestra, bands, instruments, or piano. But given the fact that his father was a distinguished vocal coach (of Metropolitan Opera "stars," no less) and that Norman himself became an organist and choir director at the tender age of 14, is his propensity for choral works really so surprising?

Read at the Academy Dinner Meeting, April 7, 2009.

Besides his composing career, Norman was a distinguished educator, having taught at Sarah Lawrence College, the Mannes School of Music, and Boston University. In fact, it was at BU, in the late seventies, that I first got to know Norman personally. I was on the music faculty, while he was dean of the School of Music—a boisterous, irrepressible man, full of energy as well as kindness.

Norman Dello Joio firmly believed that music should be essentially lyrical and must touch the heart. He was suspicious of atonality and of rigid musical systems. His attitude suited me just fine. (Already a recovering atonalist, I was fast becoming a born-again neo-Romantic.) Needless to say, Norman and I got along famously. And it was at BU that I first heard some of his most beautiful works: the Pulitzer-winning orchestral piece *Meditations on Ecclesiastes*, and the vocal work *The Lamentation of Saul*.

I last saw Norman in the mid-nineties at his East Hampton home with his lovely wife Barbara. (I was living nearby in Sag Harbor.) He was no longer so boisterous, but was still full of warmth and appreciative recollection. His career—so complete, varied, and full of creative flowering—seemed to please him, as well it should.

Although Norman Dello Joio is no longer with us, his music, with its exhilarating celebration of the human spirit, lives on—joyously!

HORTON FOOTE

1916-2009

BY ROMULUS LINNEY

After a Texas childhood, Horton Foote made his way through the ups and downs of a hardscrabble early life in New York, first as an actor, then a playwright. He learned his theatrical lessons beyond Broadway's fashions and passions. He never blinked. He never changed. His legions of plays, television dramas, films, and two recent memoirs won Academy Awards, the Pulitzer Prize, election to this Academy, which gave him its Gold Medal, and to the American Theatre Hall of Fame. He was given the National Medal of Arts by President Clinton and he received a host of other honors and awards. He loved the same woman all their married lives. He raised a fine family that is devoted to him and will always honor him. In later life he not only wrote good plays but some of his best.

I shared with Horton our Southern childhood, our veneration of William Faulkner and Katherine Anne Porter, our delight in a tall tale well-told, our admiration for the art of good acting. He was a real friend. He liked my work and he liked me. I thought of him as I think of Chekhov and, of course, Faulkner, who thought so highly of Horton's television adaptation of his novel *Old Man* that he offered to share with him half his royalties.

Knowing Horton is one of the greatest treasures of my life. But it was also fun.

Read at the Academy Dinner Meeting, November 12, 2009.

Nobody, but nobody, loved the theater like Horton. When he was in production, which was most of the time, he went to every rehearsal. When that play opened, even more amazing, he went to every performance. This is unheard of. Let me suggest why he did it.

Once we were talking to a group of playwrights, directors, and actors at a theatre we belonged to. Somehow, the afterlife came up, and Horton said he didn't think about it. It was a waste of time. But if there was a heaven and he was going to it, he hoped it would be like going to rehearsal.

Another question that day was what did he do when he couldn't think of what to write next. Horton said that never happened. He had a huge extended family from both his mother and father, plus many cousins and a whole Texas town from which to draw his characters and their conflicts. He spent his childhood eagerly listening to his loquacious Southern kin relate story after story about their relatives, in what for him became a sort of sublime gossip. It taught him to respect and revere the hardships that ordinary people, like his extended family, endure in life, and how many are tragically defeated. He recreated his Texas memories again and again, always with grace and humor, but also with the dark honesty and truth a good play requires. Of course he loved the theatre for the art he made of it. He relished its professional challenges and met them. But, beneath the skill, it was his bottomless devotion to that family and the world it came from that was the guide to which he was always faithful. His families became yours and mine, no matter who we are or where we live. Writing his plays, he lived again, for them, and watching them, so did they, for him.

He was revising a whole cycle of his plays for current productions in Hartford and New York when, a few days short of his ninety-third birthday, he died in his sleep, I like to think, ready and waiting to go to rehearsal.

LUKAS FOSS

1922–2009

BY JOHN GUARE

Before I give my tribute to my friend Lukas Foss, I have to acknowledge my deep friendship and love for Horton Foote whose tribute we've just heard. I must thank Romulus for his evocation of our friend.

Damn, it's a sad day.

I like to think of Lukas and Horton meeting here at the Academy. The sublime conjunction of words and music.

But both were so reticent I can imagine them missing each other had not Virginia seated them at the same table. Would they have liked each other? Well, yes. Horton and Lukas were two men for whom the past existed with as much immediacy as the present.

Lukas said "I conduct because I love to make love to the past."

All I can think of today is visiting Horton in Texas and his quiet happiness in showing me the site where he would one day be buried next to his beloved Lillian. Dear Daisy, who's here tonight representing her sibs Hallie and Horton Jr. and Walter, I like to think of the fearless opacity of the border your father kept between the past and the present, between life and death, which fueled his work and his life all these years. Imagine living in the same house for 90 years. As Horton said to me, "Oh no, I haven't

Read at the Academy Dinner Meeting, November 12, 2009.

lived all my life in this house. We didn't move here till I was two."

Any thought of Horton sends me back to being 15 and seeing a play on our black and white television called *A Young Lady of Property,* which made me burst into tears—the first time I ever cried in my living room over some non-domestic event. How did this play know my secrets? I looked to see who the magician was who knew my deepest yearnings? Horton Foote. I made a note to watch for other of his plays. Which I did. And one of the wonders is we became friends.

To you, Horton.

And now, dear Cornelia and Eliza and Christopher and your kids, I thank you for asking me to speak today about another friend, your husband, your father, the one and only Lukas Foss. I remember when he said to me—

I have to be careful. Our fellow academician, Richard Howard, observed, very wisely: "Ah, the eulogy—the most autobiographical of forms!"

Let's just stick to the man.

In *Baroque Variations for Orchestra,* Lukas puckishly transformed music by Bach, Handel, and Scarlatti into something brand new. He let us hear that old music with fresh ears. Stravinsky had the same impulse. But while Stravinsky would warp the old music, Lukas revered the music he was appropriating. He treated the music of Bach, Scarlatti, and Handel as sacred reliquaries around which he built his piece.

Using the word 'puckish' makes me think of a story that's been told too many times to be totally apocryphal.

The scene: A concert in the *salone* at the American Academy in Rome. The composer in residence is performing some new very difficult American music. At one point, the pianist, in a se-

ries of demanding arpeggios up and down the keyboard, loses his balance and falls off the piano stool. At that moment, by chance, Lukas Foss, passing by outside in the cortile, looks in, sees what's happening, jumps in through the window into the *salone*, runs to the piano, steps over the pianist, and starts playing the piece from the very point where the music had thrown the previous musician to the floor. Step over the pianist? Of course. The musician can take care of himself. But the music—the music—that's what's sacred.

If this leap through the tall open windows brings up images of Puck or even Peter Pan, you're not far off. Lukas was no whimsical Peter Pan, but, my god, he was Pan.

He regularly quoted Stravinsky: "I know exactly what I want to do, and then I do something else."

The anarchy of Pan.

He revered Mozart for his ability to "put things together that don't belong together" and make it sound sublime.

He described composition as the search for "the right wrong notes."

Close your eyes. Didn't Lukas even look like Pan?

Lukas, born in Berlin in 1922, had, in a detail fitting for Pan, no birth certificate. The birthday chosen for Lukas was 15 August. Even though Lukas was Jewish, 15 August is a major Catholic religious holiday in Europe—*Maria himmelfahrt*—Mary's heaven trip—the day Jesus assumed his Blessed Mother into heaven. Just look at the image of Mary's Assumption as painted by Rubens in the *Chiesa Nuovo* in Rome. Lukas would love sharing a day with this lush blonde in ecstasy flying up into heaven, accompanied by trumpeting angels playing music which he would of course write. August 15th. That's a day for Pan and Lukas to be born.

The joint presence of Lukas and Cornelia has cast a pro-

[75]

found shadow over the American Academy in Rome for over fifty years. It's where they met, when he was a fellow in 1950 and she the mere child of another fellow.

Their lifelong romance makes me think of the title of the fourth movement of Lukas' *Song of Songs*: 'Set me as a seal upon thy heart.'

A few weeks ago I was in Rome and asked Richard Trythall, who has been the long time music liaison between the city of Rome and the American Academy for a few thoughts on Lukas.

Richard was thrilled to do so. "Lukas was a wunderkind. Just think," Richard remembered, "Lukas made his debut as a conductor with the Pittsburgh Symphony at the age of 17. By 1940 he was at Tanglewood studying conducting with Koussevitzky and composition with Hindemith. In 1944, at age 22, Koussevitzky hired Lukas to be the pianist of the Boston Symphony so he "could compose."

And compose he did.

Richard remembered first confronting Lukas's *Solo for Piano*: "You look at the score in terror. Fifteen minutes of an unbroken line of notes. Not a rest. It's constantly changing, merging several styles into his sensibility. But playing it, you're aware of his control over every moment of the piece—there is nothing in it that is not thoughtout—it is a masterpiece."

Lukas was, as the Italians say, *in gamba* [meaning, he really knew what he was doing].

Richard remembered a concert of new music Lukas gave in Rome. As an encore, he spontaneously played Bach and Chopin —an incredible feat of memory—the music was in his fingertips.

And this was the surprise—Richard suddenly burst into tears telling me this.

I have to go into some autobiographical aspects at this point

for it was Lukas and Cornelia who first told my wife Adele and me many years ago of the wonders of the American Academy in Rome. Thanks to them, that other Academy has been the central focus of Adele's life, our life, for the past twenty years. Thank you, Lukas.

In 1953, because of his encyclopedic musical knowledge and his success as an atonal composer, Lukas was the logical choice to succeed Arnold Schoenberg as the head of the composition department at UCLA where he formed the Improvisation Chamber Ensemble to create new work that would challenge "the tyranny of the printed note" and restore improvisation to the concert stage. Improvisation had once been the norm in the time of Mozart but had gone out of favor. In this age of jazz, it's time for it to re-enter the modern concert stage.

In 1963, he left Los Angeles to become director of the Buffalo Philharmonic. I could imagine some people thinking, Buffalo! A backwater. Instead, Lukas joined forces with composers on the faculty of the State University of New York at Buffalo and formed the Center of the Creative and Performing Arts, bringing together young performers and composers, transforming Buffalo into the locus of new music in the second half of the twentieth century.

In the 1960s and '70s, thanks to Lukas, Buffalo was the only place in America where you could hear new music from Europe, the U. S., and Canada. Once a year, Lukas would bring his group of young musicians to New York for an appearance at Carnegie Hall. Thanks to Lukas, what Black Mountain College was to the arts, what Bennington was to modern dance, what North Beach was in the 1950s to poetry, so Buffalo was to music.

Nils Vigeland, Chair of the Composition Department at the Manhattan School of Music, who grew up in Buffalo, recalls:

"It was one of those kinds of places the way people talk about Vienna in 1900-1910."

Lukas put his imprimatur on new music and never gave up the task. What a gorgeous life. His opera *Grimalkin* produced by New York City Opera, his amazing tenure with the Brooklyn Symphony Orchestra, his ten-year directorship of the Festival of Music in the Hamptons.

His fervor never diminished to the end.

I was talking to fellow academician John Corigliano about Lukas. John said "What I can never get over is that after the premiere of Lukas' *Song of Songs*, he got a fan letter from Igor Stravinsky! Imagine being 25 years old and getting a fan letter from Igor Stravinsky who was famous for his lack of generosity to other musicians." John asks if I'm aware of "how important *Song of Songs* was to the career of Leonard Bernstein, how Lenny's music changed after hearing *Song of Songs*. Do you realize the far ranging influence of Lukas Foss?"

I only could think of how comfortably he fit into our lives.

If Stravinsky's fan letter was atypical of him, Leonard Bernstein did something equally unimaginable in 1960 when he conducted the premiere of another Lukas masterpiece, *Time Cycle*. At its conclusion as the applause quieted, Lenny turned to the audience and said, "This piece is so important that it cannot be appreciated at one hearing." He lifted his baton and, for a surprised and delighted audience, played the entire piece once more. Is *Time Cycle* the only work in history that received two performances at its premiere?

Oh, Lukas, if we could only lift our batons, see you appear in that window, and ask you to leap in and repeat your life all over again.

GEORGE PERLE

1915–2009

BY YEHUDI WYNER

George Perle was born in Bayonne, New Jersey, in 1915. As a little boy of seven, he heard his cousin Esther play the first of Chopin's *Trois Nouvelles Études*. He found himself, in his own words, "extraordinarily moved," and this reaction ignited what proved to be a passionate, lifelong commitment to music.

Perle's outstanding musical gift—allied to a penetrating intelligence, an appetite for exploring and cultivating the new—compelled him to pursue a varied and productive career, writing, teaching, and, above all, composing. His several books on serial music and atonality, on the major works of Alban Berg as well as significant compositions of Schoenberg, Webern, Krenek, Babbitt, and others, are considered essential texts for the understanding of the revolutionary developments of the 20th century. In his own composition he evolved a system of 12-tone tonality, only distantly related to serial technique.

Perle's catalogue of compositions is copious and varied. It includes works for solo instruments (especially piano), songs and choruses, chamber works for diverse ensembles, works for larger instrumental ensembles, five wind quartets, several string quartets, piano concertos, and compositions of symphonic scale.

The quality of the craft is exemplary. Nothing is shoddy,

Read at the Academy Dinner Meeting, April 7, 2009.

nothing thrown away. The imagination, the energy, the wit, never flag. What is especially surprising is that this art, so tightly controlled, so meticulously organized, releases assaults of Dionysian passion which seem impulsively improvised and yet are immediately integrated into the governing context. We have the security, so to speak, of a rational, dependable vehicle which encourages the unexpected irruption of shapes and figures that could not be anticipated and yet that immediately earn their essential place in the discourse.

I did not know George well. My acquaintance with his music came late. I clearly recall the moment over 20 years ago when his music invaded my consciousness. It was a performance of his *Etudes for Piano*, splendidly played by Seymour Lipkin—wonderful music, original, elegant, powerful, convincing. Before this, where had I been? Since that epiphany, Perle's music became very present on my radar screen, and I followed performances of his music with alert anticipation. With each new piece the conviction that this was music of the highest value was deepened and enlarged.

My impression of George was that he was shy, retiring, private, reserved. For a long time I was unaware of his puckish wit and of his rapier-like critical intelligence.

In contrast to his apparent reserve, his music presents a commanding assurance, unflagging animation, and invariable coherence as well as a rich repertory of high-spirited humor. No signs of self-pity, no inflated bathos, no adolescent narcissism. The music sets forth arresting shapes, vivid articulations, and exhilarating oppositions, which explode into our perception. At every moment one is aware of various kinds of order marked by symmetry, precision, clarity, and transparency. The instrumental writing, while often diabolically demanding, is also brilliantly

idiomatic and full of color and character. Grossness, gratuitous violence, mere theatrical shocks are unthinkable. Even at events of violent intrusion—dramatic awakenings so to speak—the musical elements—notes, voicings, and textures of the attack—are connected organically to the fabric of the composition. Nothing vulgar, nothing small-minded, petty, or cosmetically enhanced enters this world.

In his book *Notes of an Apprenticeship*, Boulez quotes François Florand speaking about the music of Bach. Florand says:

> Bach's "concert of voices". . . leads to a progression that comes entirely from the melodic current itself, a little stream that one sees increasing without apparent external cause, without affluents or glaciers or storms, solely by the contribution of mysterious subterranean springs. It is a procedure which is formed of an interior accumulation of energy, of emotional force, to the point at which the composer and the listener are saturated as though intoxicated.

Florand continues his analysis by pointing out that Bach's "delirium" is "lucid, his intoxication conscious…always contained by a will and an intelligence that never for a second sleep."

I find this formulation relevant to the music of George Perle and the procedures by which it is achieved. Bach's music is not about him personally, not about his life experience as an individual. And yet the uniqueness, the individuality and the vividness of the expression, the vitality of the intelligence and the depth of human understanding transmit a communication of the most direct relevance to all of us, and, paradoxically, to each of us.

I believe that these qualities are the basic components of Perle's art. I cannot conceive of a higher praise of Perle's music than proposing these parallels with the music of Bach, our giant of giants.

Describing music is largely a futile exercise, a bit like shadow boxing. What we really want is "Not ideas about the Thing, but the Thing itself," to quote Wallace Stevens. An anecdote about Beethoven, perhaps apocryphal, is relevant. Following a performance of one of his sonatas, a person approached him and asked him what the music meant. Beethoven reacted with a gesture of disgust, then seated himself and played the sonata all over again.

And so to proceed to what is most important, let us listen to three examples of George's music, regrettably short because of our time constraint.

The first is from *Brief Encounters*, his *String Quartet #9*, composed in 1998. We hear a clear exposition of elements, playful, animated yet elusive. Seamlessly this dissolves into an episode of warm, heartfelt lyricism. The rest is extension, development and return, always varied and modified. The conclusion surprises.

Our second example is a short excerpt from the *Second Piano Concerto* dated 1992. We've allowed ourselves two minutes, fifty seconds of a nine-minute movement.

The opening is brilliant, with clear textures, clear phrases, and sharp percussion punctuations. Such an opening salvo is intended to capture our attention with images we can identify and remember. A contrasting section follows with delicate figures and sequences. The discourse is witty, affectionate. The harmony inflects. Lots of laughter, lots of mystery.

And finally, as an aubade, the *Adagietto con affetto from Chansons Cachées. Chansons Cachées*: might this be a suggestive subtitle

for all of Perle's music? The tender, caressing affection of this short piano piece makes it irresistible.

The pianist is Shirley Rhoades Perle.

JOHN RUSSELL

1919-2008

BY FRANCINE DU PLESSIX GRAY

I'll begin with a passage from John Russell's book on Paris in which he writes about that city's hotels:

"Every seasoned visitor has a list: hotels near the Rue Monge, where the deep-frying never stops and wayward youths fall unconscious in the street; suburban hotels in which the frame comes away with the door; hotels where even the arrival of an orangutan could not disturb the fairy-tale slumber, the lace-curtained indifference of the personnel; hotels where the eight-foot high windows open inward, and need the intervention of a professor of jiu-jitsu…."

I was drawn to this passage because it typifies the spry felicity of John Russell's prose, but also, I suspect, because it's about diversity, and John loved to depict diversity, and diversity was central to his vocation. Most of you probably think of him as a brilliant art critic, but that's only one narrow hue in the amazing rainbow of Russell's career. For beyond his books on Seurat, Matisse, Max Ernst, Francis Bacon, and numerous other artists, he wrote travel books on Switzerland, Paris, and London; a biography of the great German conductor Erich Kleiber; a book on the palaces of Leningrad; several highly regarded translations of contemporary French novelists; and the catalogue copy for the Beaubourg's exhibition of Bonnard, which he wrote in perfect French. His book

Read at the Academy Dinner Meeting, April 7, 2009.

Reading Russell offers even a broader canvas, containing essays on subjects as varied as Pushkin, Dietrich Fischer-Dieskau, Beatrix Potter, luggage, and the beauties of the Merritt Parkway. And when I'm confronted with Russell's wondrous curiosity, with the universal range of his interests, I'm reminded of the legendary 16th-century Italian philosopher Pico della Mirandola, who has long been seen as the prototype of what we call the Renaissance man, and whose highly syncretic, conciliatory vision led him to be called, by his contemporaries, "The Prince of Harmony."

"The Prince of Harmony!" What phrase could better describe John Russell, the scholar of legendary integrity and courtliness, and the quintessential syncretist of our time, who deemed the Merritt Parkway and the vagaries of luggage to be as worthy of commentary as the works of Joan Miró. Moreover, and most importantly for his vocation, this Prince of Harmony detested writing what he called "punitive" criticism; Russell wrote exclusively with the purpose of "communicating his enthusiasm" (his phrase) about art, music, and literature, an ever chivalrous attitude which led some readers to think of him as too genteel. "There are artists whose work I dread to see yet again," he once said, "dance dramas which in my view have set back the American psyche several hundred years, but it has never seemed to me much of an ambition to go through life snarling and spewing."

John Russell was born in 1919 in Fleet, near London. He studied philosophy and politics at Magdalen College, Oxford. During the war years he worked for British Naval Intelligence and began to contribute reviews of books, plays, and musical performances to magazines such as Cyril Connolly's *Horizon*. It is Ian Fleming, who served alongside John in Naval Intelligence, who helped him to get a job at the *Sunday Times* of London, where John was soon promoted to chief art critic, a post he held

until 1975, when the *New York Times* hired him to be its chief art critic. In the post-war decades his ability to communicate enthusiasm well served the artists emerging in his own country. Such painters as Henry Moore, Francis Bacon, and Bridget Riley were barely known to the general public until John began to dedicate monographs to their work; as his colleague Picasso scholar John Richardson, has said, Russell almost single-handedly "put British painting on the map."

There is a central feature of John's working habits I'd like to mention, one best denoted by the Italian word *sprezzatura*, best translated, if you absolutely have to put it in three words, as "seemingly nonchalant ease." The word was first featured in Castiglione's book "The Courtier," which defined the prototype of the "Renaissance man" as we know him to this day—the gracious John Russell kind of citizen deeply versed in a variety of skills and disciplines. The earmark of the true Renaissance man, Castiglione tells us, is that through his *sprezzatura* he avoids showing any effort in the accomplishment of his skills, and retains a serenity of bearing throughout the most difficult labors. Michael Kimmelman, currently the chief art critic for the *New York Times*, is eloquent on this issue of John's own *sprezzatura* as he describes the days when they were working together at the paper. "There we were slaving at our computers," he says, "sweating our deadlines, draft after draft after draft, and in walked John in his bright pink striped shirt and chequered jacket, and after smiling a hello to us he'd sit down and set his fingers lightly to the keyboard and *presto*—in less than an hour his article was finished without a word out of place. He did not know what a draft was."

I must inevitably address the issue of John's stutter, for it had a profound impact on his vocation: it was an affliction he suffered from earliest childhood, and his widow, the distinguished

lecturer and writer Rosamond Bernier, tells me that he decided to be a writer as a very small boy because writing would be a substitute for speaking. Mind you, there were interesting exceptions in which John did not ever stutter. He never stuttered when he spoke French or German, neither did he stutter when he read a prepared statement or when he gave a toast. I remember one New Year's Eve in Egypt in the late 1970's: Rosamond and John and I were on the same winter cruise on the Nile and at midnight John raised his glass to the assembled company and gave a very long toast in the most mellifluous diction you can imagine. Rosamond (whom I've known, by the way, since 1944) tells me of an episode at the hospice in the Bronx where John spent his last months: he was enormously appreciative of every little thing his nurses did for him, and treated them like duchesses, showed his appreciation by kissing the bewildered ladies' hands as he addressed them in French—he wished to address them in his most melodious manner.

Last but hardly least, I want to say a word about the central role of Rosamond Bernier in the last 35 years of John's life, the very passionate nature of their love, and the depth of their esteem and admiration for each other. In the years when Rosamond lectured at the Metropolitan, John would wait with her in the wings until she went on stage, then go and take his seat in the audience; and when she'd ended her talk he'd swoop her into his arms and unfailingly tell her "That was your *best*." As Rosamond puts it, "We were each other's greatest fans." When they were first courting, in the early 1970's, a friend who glimpsed them dining alone in a restaurant describes their displays of affection as being, I quote, "so erotically charged that they bordered on the prurient." I witnessed a poignant token of their in-separate-ness right here at the Academy, two years ago, at our January members-only din-

ner, when John's mind was just beginning to fail. Dinner was over and John and I and a few others had gathered at the elevators and John said "Ah, I must find Rosamond," and started walking back to the dining room. I tugged at his sleeve and said, John, members only tonight, Rosamond is at home, waiting for you. "Nonsense," he said adamantly, "She is always, everywhere at my side." So I whipped out my cell phone and called Rosamond and had her speak to John; she told him she was waiting for him at home and we got him into a cab and took him to his door but as he sat in the cab he kept repeating, with a slightly bewildered air, "But she is always at my side."

It is so fitting, it is so just, that this extraordinary man met an equally extraordinary woman, and enjoyed one of the most ideal marriages of our time.

W. D. SNODGRASS

1926-2009

BY DONALD HALL

On January 13th of 2009, W. D. Snodgrass died at his house in Erieville, New York, eight days after he turned 83. With him at his death was Kathy, his wife of 28 years, and the daughter of his *Heart's Needle*—published fifty years earlier. When Snodgrass learned, in September 2008, that he had incurable lung cancer, he undertook no treatment for the disease but committed himself to the care of hospice. His widow has written about the tender palliative care he received and the ease of her husband's death.

In 1954, by chance, I first read Snodgrass poems in manuscript. I was dazzled. The work was witty, accomplished in metrical form, written in vivid common language. It did not resemble the ponderous pentameters of its time. The poems were public about feelings, intimate and self-exposed. I wrote him, and a friendship began. We met, read our poems together, picnicked, and talked—but mostly our friendship expressed itself in letters. We wrote about the work of other poets, about each other's work, about the birds he saw out his window, and about disasters of personal life. There must be a thousand letters, even after disasters turned into contentment.

When Snodgrass published *Heart's Needle* (1959), he invented what M. L. Rosenthal called confessional poetry. De—as his

Read by Charles Wright at the Academy Dinner Meeting, November 12, 2009.

friends called him—came to dislike the term. The title sequence concentrates on his misery in losing his daughter to divorce. Unlike earlier autobiographical poems, *Heart's Needle* was wretched, guilty, and negative in its revelations. It was also affectionate and tender: "Winter again and it is snowing;/ Although you are still three,/ You are already growing/ Strange to me."

His Iowa teacher Robert Lowell spoke of Snodgrass as the first confessional poet, and acknowledged that Snodgrass influenced his own *Life Studies.* On the jacket of *Heart's Needle* he wrote, "Snodgrass is the best new poet for years...." The early poems were well made, clear, and plain spoken, but without great formal invention. Snodgrass became foxier. Following *Heart's Needle,* he wrote a better book, *After Experience* (1967). Because the first book won the Pulitzer (1960), no one paid attention to the second.

Maybe the formal intricacy of his ongoing work came from attention to music. He played several instruments, and translated songs from German (and other languages) with painstaking ingenuity. In his multiplication of rhyme and alteration of line length, he developed more stanzaic invention. In 1977 he published *The Fuhrer Bunker* about the evil leaders of the third Reich, perhaps his best and least appreciated work. Over many years he tinkered with his *Bunker,* adding and changing, and *The Complete Cycle* did not appear until 1995. Some critics complained that the book humanized the Nazis. In effect, he Nazified humans. If Nazis were men and women, Snodgrass noted, perhaps we share something with them. The book contains villanelles and sonnets executed with customary brilliance, but his form was not limited to forms. Here, and in further poems, he invented new ways to

march lines down the page, counting not only syllables but let-ters, doubtless with numerical schemes that I have never deci-phered. In our correspondence we agreed: the efficacy of such devices had nothing to do with the reader. Such self-imposed obligations benefited the poet, enforcing minute attention to the text, making the writer constantly re-think, re-invent, re-vise.

Snodgrass wrote more than thirty books including mem-oir and critical essays. He collaborated with the artist DeLoss McGraw, producing sequences, poems and paintings, that were often witty and even funny. His *De-Compositions—101 Good Poems Gone Wrong* (2001) was comical and instructive. On the left-hand side of the page was the real poem, perhaps a sonnet by Shake-speare, and on the opposite page his own revoltingly, inventively bad reduction.

In 2006 he published a new and selected poems, *Not for Spe-cialists*. The new poems, almost 60 pages, contain some of his best work. A week before he died, W. D. Snodgrass dictated his last revisions to his last poem.

STUDS TERKEL

1912–2008

BY CALVIN TRILLIN

Studs Terkel's accomplishments as America's pre-eminent listener were all the more remarkable when you consider the fact that he happened to have been a prodigious talker. He was, in other words, a monument to restraint. A couple of times, I reversed roles with Studs—I interviewed him for an hour on stage—and each time I was tempted to ask him the first question, take off my lapel-microphone, and quietly join the audience. He could have easily held forth for an hour, segueing smoothly from some thoughts on jazz to his soap-opera career playing gangsters to the dinner-table conversations at the men's hotel his mother ran to his encounters with some Keystone Kops enforcing the blacklist to happy times in his favorite Chicago saloon, Ricardo's, where one of the waiters was cued to stroll over to the table and join him in the Spanish Civil War song "Los Cuatros Generales."

One of those stage interviews was in San Francisco and one in New York, but wherever Studs was he brought Chicago with him. Chicagoans were the people he interviewed for the book that began his transformation of oral history, *Division Street: America*—the first in a series of volumes that included *Hard Times: An Oral History of the Great Depression* and *Working* and *The Good War*, which won the Pulitzer Prize in 1985. It was in Chicago that, for

Read at the Academy Dinner Meeting, April 7, 2009.

forty-five years on station WFMT, he interviewed a remarkable array of musicians and writers and academics—often introducing an interview with some piece of music he considered relevant to his guest, even if the guest, lacking Studs's encyclopedic knowledge of music and his gift for spinning out connective tissue, had never heard of it. In the early days of cable television, Studs and I did a talk show in which we chatted with a panel of people who were distinguished in a particular art form—three divas, say, or three architects—and what amazed me was that Studs seemed to know nearly all of them. It became clear that illustrious visitors to Chicago were taken to see Studs in the way that in a past era illustrious visitors to Chicago had been given a tour of the stockyards. Once, somebody on the show mentioned Jane Austen, and I said, "If she ever went through Chicago, Studs knew her."

If an author showed up at WFMT toward the end of a book tour, he was likely to have repeated phrases from his book so often that they were beginning to have a depressing similarity to the flight attendant's announcement about seat backs and tray tables. Then, after the introductory piece of music, Studs would open up his copy of the book, which had been heavily underlined with a broad black pen, and read a few passages in that gravelly voice that somehow made the words sound fresh again. The author would find himself thinking, "Hey, that's not half bad!" Foundations that wanted to buck up American writers didn't really have to send them to villas in Italy; they could have simply had the writers interviewed by Studs. You wouldn't even have had to air the results.

When Studs got into a Chicago taxi cab—which he often did, since he'd never learned to drive a car—the cabbie almost invariably realized that he had one of the city's iconic figures in

the back seat. There usually followed a conversation in which Studs, through his questions, displayed a remarkable familiarity with the driver's old neighborhood, whether the neighborhood was Back of the Yards or Nigeria. The almost instantaneous connection Studs made with the driver was a reminder that this man, who had interviewed Leonard Bernstein and Bertrand Russell and Ralph Ellison and Zero Mostel and Margaret Mead, created his most enduring work by gathering the thoughts of ordinary Americans—the people he sometimes referred to as "the uncelebrated"—on their struggles and their daily labor and even their deaths. They shared those thoughts with him, I think, partly because, like the writers who were lifted out of book-tour torpor on WFMT, they sensed that his curiosity and his generosity of spirit embraced everyone, without regard to rank or station.

Not long after Studs died, the *New York Times* published in the Arts section what was labeled an appraisal of his work. The writer, after acknowledging some of Studs's accomplishments, said that, upon close reading, a book such as *Working* revealed Studs to be someone who had molded his interviews to "fit models shaped by Marxist theory." The article ended with a fact that seemed meant as the clincher for this interpretation of Studs Terkel as essentially a propagandist—the revelation that he had once given a blurb to a book by William Ayers, the Chicago education professor who in the sixties had been a founder of the violent Weatherman faction of S. D. S.

The article incensed some of us who loved and admired Studs, but I cooled down a bit after I realized how Studs would have reacted. I could picture him at Ricardo's. He's wearing a blazer and his trademark red-checked shirt, with the top button unbuttoned and a red tie pulled down to half mast. He's gesturing with a half-smoked cigar. He's telling a story about how in

the '50s he was informed by a network flunky that he couldn't work on Mahalia Jackson's show if he refused to sign a loyalty oath, and Mahalia Jackson ended the conversation by saying, "If Studs don't write, Mahalia don't sing." Pausing for a quick pull on his cigar, Studs says, "So fifty years later, there's this guy in New York who reveals me to be a dangerous blurbist." That, in turn, reminds Studs of the attempts to paint Barack Obama as a disloyal radical because of his acquaintanceship with Ayers, and that leads to an arcane analysis of how politics on the South Side differ from politics in certain other Chicago neighborhoods. During that exegesis a waiter on his way to another table suddenly swerves and comes over to stand next to Studs. Then they treat us to a verse or two of "Los Cuatros Generales."

JOHN UPDIKE

1932-2009

BY J. D. McCLATCHY

John Updike was a member of this Academy for 45 years. He was not quite the youngest person ever elected, but nearly. Over those years he was awarded prizes (including the William Dean Howells Medal and the Gold Medal for Fiction), he served on every conceivable committee, he presided as both Secretary and Chancellor, he gave the Blashfield Address, he edited *A Century of Arts and Letters*, the Academy's centennial history. I dare say he knew more about this institution than anyone among us today, and loved it enough to both cherish its traditions and gently mock them. On the one hand, he parodied us wittily in his *Bech* books; on the other, he once wrote a magazine squib about 155th Street as his favorite spot in Manhattan. "New York's claustrophobia lifts in this vicinity," he wrote, "the buildings throw short shadows, and the neighborhood's stately elements—the terrace, the walled cemetery, the Episcopal church across Broadway— stand as a kind of pledge the past has made to the future." And when he wrote about what happens inside this building . . . well, here is his sardonic little sonnet from 1992, called "Academy":

> The shuffle up the stairs betrays our age:
> sunk to polite senility our fire
> and tense perfectionism, our curious rage

Read at the Academy Dinner Meeting, November 12, 2009.

to excel, to exceed, to climb still higher.
Our battles were fought elsewhere; here, this peace
betrays and cheats us with a tame reward –
a klieg-lit stage and numbered chairs, an ease
of prize and praise that sets sheath to the sword.

The naked models, the Village gin, the wife
whose hot tears sped the novel to its end,
the radio that leaked distracting life
into the symphony's cerebral blend.
A struggle it was, and a dream; we wake
to bright bald honors. Tell us our mistake.

At my age, I am rarely surprised any longer by newspaper headlines. But I was genuinely shocked, last January, to read of John Updike's death. Why had I thought *he* would live forever, when all of us merely think we will? It was only later, reading the work of his last months, that one could see him wondering the same thing, watching with a wry detachment and a sudden fresh upwelling of old memories what had suddenly become his own last act unfold. Just a month before he died, he wrote a poem about two Shillington High School classmates of his who must that day unexpectedly have walked into the lamplight of idle consciousness, and whom he addresses—after a very specific account of their lives a half century earlier—this way:

Dear friends of childhood, classmates, thank you,
scant hundred of you, for providing a
sufficiency of human types: beauty,
bully, hanger-on, natural,

twin, and fatso—all a writer needs,
all there in Shillington, its trolley cars
and little factories, cornfields and trees,
leaf fires, snowflakes, pumpkins, valentines.
To think of you brings tears less caustic
than those the thought of death brings. Perhaps
we meet our heaven at the start and not
the end of life. Even then were tears
and fear and struggle, but the town itself
draped in plain glory the passing days.

This is like a little fable of his career: to have taken the types life offers, and rendered them with such detail as to make a moral allegory of the ordinary. And those final phrases—*plain glory* and *passing days*—were his abiding themes, despite the lavish ways he used to evoke them. No writer since his beloved Nabokov had manipulated, massaged, and mastered English prose as John Updike did. He laid down sentences like marble inlay in a grand corridor that led to the inner recesses of the heart. To linger again over those sentences is to admire a virtuosity so rare and exhilarating that we sometimes forget it was in service to something considerably beyond its own giddy pleasures.

But even before they got to the new sentences, writers picking up a just-published book by John Updike would invariably panic. The print size on the ad card got smaller over the years to accommodate his titles. After five dozen of them, I think even the experts were confused about the exact number. Their range was prodigious—the novels and story collections, the poems and essays—as was his instinct to surprise us with a new narrative experiment or with an expertise in something obscure and compelling. But scanning those columns of books, what was most daunting

at the heart of them was the Rabbit Angstrom books, long since properly gathered into a single massive volume that stands without question as the greatest novel of postwar America.

Early on, he told an interviewer, "My subject is the American Protestant small town middle class. I like middles. It is in middles that extremes clash, where ambiguity restlessly rules." As a realist, he knew that the novelist's task is not merely the accumulation but the illumination of details. And that, in turn, is accomplished not merely by a keen observation of the murky secrets repressed behind the bright façade, but by revealing that tension between inner and outer in sentences of astonishing lyrical grace and rhetorical power. If sex and religion preoccupied many of his chronicles of American life, it is because he wanted to discover how we cling to the moment and to something beyond the moment, or what he once called "the tension and guilt of being human."

His least ambiguous faith, of course, was in language itself. But for a novelist who dealt so often with infidelity, he had a religious temperament. In a preface to one of his favorite novels, Thornton Wilder's *The Eighth Day*, John said of Wilder that he "kept religion's bias—its basic gaiety," and in the novel itself, Wilder says that "faith is an ever-widening pool of clarity, fed from springs beyond the margin of consciousness." A bias that clarifies, a joy on the margins—these are about as good a definition of a contemporary American's religion as any. John wouldn't have wanted to be in any world but a fallen one, and one that had fallen in a peculiarly American way, with our Puritan roots, with our evangelical fringes, with our restless, greedy, generous ambitions. Even in what we don't know, we know more than we suspect, are more than we hope. John Cheever once said that the characters in Updike's novels perform their lives in a spiritual landscape of whose grandeur they are unaware, that continually escapes them.

In Harry Angstrom, he embodied all of these contradictions. Rabbit is one of literature's great characters—rabbitty and angst-ridden anti-hero who thought Ronald Reagan was like God in that "you never knew how much he knew, nothing or everything." In the *Rabbit* tetralogy, Updike used everything to explore the nothing. "Boys are playing basketball around a telephone pole with a backboard bolted to it. Legs, shouts. The scrape and snap of Keds on loose alley pebbles seems to catapult their voices high into the moist March air blue above the wires." So *Rabbit Run* opens, with Harry watching them play. "He stands there thinking, the kids keep coming, they keep crowding you up." Hundreds of pages later—pages with the amplitude and address of the great 19th-century novels—*everything* has happened (happened in suburban beds and convenience stores and cars and sailboats, in copper beeches and on golf courses) until the nothing happens, and we look back on Rabbit's life as our own, our century's, our culture's. It is our great anatomy of desire. In the Rabbit books, Updike wrote of an American's empty dreams and passionate loneliness. The dreams are empty, so that there is room to move around in them, to change them. The loneliness is passionate because each of us falls in love with being alone.

Few writers are given the privilege of writing down their time. And beyond his skills at the typewriter, he was a true bookman. His longtime editor at Knopf, Judith Jones, remembers his sending in a new manuscript every year, and considering it a point of honor that it make money. But there was never an agent, a contract, or an advance. He only cared about the book. He pestered the art department to design what was in his mind's eye. He had top stain and full-cloth bindings to the end. In the days of letterpress, he would pick up the first copy of a new novel, and smell the pages, run his hand over the type to feel the ink.

He was also a patient writer, a practical one. As *Rabbit Run,* which appeared in 1960, was being readied for publication, he became privately worried that its raw take on things like sex might get him hauled into local courts across the land. He had a family, after all, and tuitions to pay. So he suggested to Mr. Knopf that the firm's lawyers read the manuscript. They did, and came back with pages of anxious notes. Mr. Knopf telephoned John with the bad news, but was told that John was teaching Sunday school class and couldn't be disturbed. In the end, much of what readers of the day would have considered to be smut was deleted from the novel, and John waited patiently as, edition by edition, over 15 years or so, bits of it were folded, like beaten egg white, back into the original batter. By the time the whole original text was finally between covers, the temper of the time had changed, and nobody ever noticed what had been done.

John Updike was, in every sense, our first man of letters, a man made of words which he chose—in ways always surprising and sublime—to give back to us, shaped like ourselves, like our lives, our sorry hearts. He let us see and understand them, love and wonder at their textures and terrors. His books, in the poet's phrase, beheld "Nothing that is not there and the nothing that is."

There is now an empty chair in this room, and always will be.

PART THREE

Events

WEDNESDAY, JANUARY 21

Dinner for Members Only

TUESDAY, APRIL 7

Dinner for Members and Guests

WEDNESDAY, MAY 20

Ceremonial

THURSDAY, NOVEMBER 12

Dinner for Members and Guests

2009

American Academy of Arts and Letters
BOARD OF DIRECTORS

[107]

Members of the Academy

DEPARTMENT OF ART

Lennart Anderson
Richard Artschwager
William Bailey
John Baldessari
Will Barnet
Jennifer Bartlett
Hyman Bloom*
Varujan Boghosian
Lee Bontecou
Louise Bourgeois
Vija Celmins
John Chamberlain
Christo
Chuck Close
Henry N. Cobb
Jim Dine
Mark di Suvero
Lois Dodd
Rackstraw Downes
Peter Eisenman
Marisol Escobar
Eric Fischl
Mary Frank
Helen Frankenthaler
Jane Freilicher
Frank Gehry
Romaldo Giurgola
Michael Graves
Red Grooms
Charles Gwathmey*
Hugh Hardy
Steven Holl

Richard Hunt
Robert Irwin
Yvonne Jacquette
John M. Johansen
Jasper Johns
Lester Johnson
Wolf Kahn
Alex Katz
Ellsworth Kelly
William King
Alfred Leslie
David Levine*
Jack Levine
Maya Lin
Robert Mangold
Brice Marden
Richard Meier
Catherine Murphy
Bruce Nauman
Kenneth Noland
Claes Oldenburg
Laurie Olin
Nathan Oliveira
Philip Pearlstein
I.M. Pei
Cesar Pelli
Judy Pfaff
James Stewart Polshek
Martin Puryear
Paul Resika
Kevin Roche
Dorothea Rockburne

*Died in 2009.

James Rosenquist
Susan Rothenberg
Edward Ruscha
Robert Ryman
Richard Serra
Joel Shapiro
Cindy Sherman
Kiki Smith
Kenneth Snelson
Nancy Spero*

Wayne Thiebaud
George Tooker
Billie Tsien
Cy Twombly
Robert Venturi
Ursula von Rydingsvard
Tod Williams
Jane Wilson
Andrew Wyeth*

DEPARTMENT OF LITERATURE

Daniel Aaron
M.H. Abrams
Renata Adler
Edward Albee
Isabel Allende
Kwame Anthony Appiah
John Ashbery
Louis Auchincloss
Paul Auster
Russell Baker
Russell Banks
Amiri Baraka
John Barth
Jacques Barzun
Ann Beattie
Eric Bentley
Frank Bidart
Harold Bloom
Robert Bly
T. Coraghessan Boyle
Robert Brustein
Hortense Calisher*
Robert A. Caro

Evan S. Connell
Robert Coover
Don DeLillo
Joan Didion
Annie Dillard
E.L. Doctorow
Deborah Eisenberg
Louise Erdrich
Jules Feiffer
Lawrence Ferlinghetti
Horton Foote*
Richard Ford
Paula Fox
Ernest J. Gaines
William H. Gass
Henry Louis Gates, Jr.
Peter Gay
Louise Glück
Mary Gordon
Jorie Graham
Francine du Plessix Gray
Stephen Greenblatt
John Guare

*Died in 2009.

Allan Gurganus
A.R. Gurney
Donald Hall
Jim Harrison
Robert Hass
Shirley Hazzard
Edward Hoagland
John Hollander
Richard Howard
Ada Louise Huxtable
John Irving
Diane Johnson
Justin Kaplan
Donald Keene
Garrison Keillor
William Kennedy
Jamaica Kincaid
Galway Kinnell
Yusef Komunyakaa
Tony Kushner
Harper Lee
Philip Levine
Romulus Linney
Alison Lurie
Janet Malcolm
David Mamet
Peter Matthiessen
J.D. McClatchy
David McCullough
John McPhee
W.S. Merwin
Lorrie Moore
Toni Morrison
Paul Muldoon
Albert Murray
Joyce Carol Oates
Cynthia Ozick

Robert Pinsky
Richard Poirier*
Reynolds Price
Richard Price
Annie Proulx
Philip Roth
Oliver Sacks
James Salter
Wallace Shawn
Sam Shepard
Charles Simic
Jane Smiley
William Jay Smith
W.D. Snodgrass*
Gary Snyder
Elizabeth Spencer
Robert Stone
Mark Strand
James Tate
Paul Theroux
Calvin Trillin
Anne Tyler
John Updike*
Helen Hennessy Vendler
Gore Vidal
Rosanna Warren
William Weaver
Edmund White
Elie Wiesel
Richard Wilbur
C.K. Williams
Joy Williams
Garry Wills
Lanford Wilson
Tom Wolfe
Charles Wright

*Died in 2009.

DEPARTMENT OF MUSIC

John Adams
Samuel Adler
T.J. Anderson
Dominick Argento
Milton Babbitt
Leslie Bassett
Robert Beaser
Jack Beeson
William Bolcom
Martin Bresnick
Elliott Carter
Chou Wen-chung
Ornette Coleman
John Corigliano
George Crumb
Mario Davidovsky
David Del Tredici
Carlisle Floyd
Lukas Foss*
Philip Glass
John Harbison
Stephen Hartke
Karel Husa
Betsy Jolas

Leon Kirchner*
Ezra Laderman
Peter Lieberson
George Perle*
Shulamit Ran
Bernard Rands
Steve Reich
Ned Rorem
Christopher Rouse
Frederic Rzewski
Gunther Schuller
Joseph Schwantner
Stephen Sondheim
Steven Stucky
Augusta Read Thomas
Francis Thorne
Joan Tower
George Walker
Robert Ward
Olly W. Wilson
Charles Wuorinen
Yehudi Wyner
Ellen Taaffe Zwilich

American Honorary Members

Woody Allen
Trisha Brown
Merce Cunnigham*
Yo-Yo Ma
Irving Penn*

Martin Scorsese
Paul B. Taylor
Twyla Tharp
Robert Wilson
Frederick Wiseman

*Died in 2009.

Foreign Honorary Members

Magdalena Abakanowicz
Chinua Achebe
David Adjaye
Bella Akhmadulina
Tadao Ando
Louis Andriessen
Bei Dao
Harrison Birtwistle
Yves Bonnefoy
Pierre Boulez
Anthony Caro
Caryl Churchill
Francesco Clemente
J.M. Coetzee
Charles Correa
Anita Desai
Margaret Drabble
Henri Dutilleux
Umberto Eco
Norman Foster*
Lucian Freud
Brian Friel
Carlos Fuentes
Athol Fugard
Mavis Gallant
Gabriel García Márquez
Alexander Goehr
Nadine Gordimer
Sofia Gubaidulina
Andreas Gursky
Zaha Hadid
Václav Havel
Seamus Heaney

Hans Werner Henze
David Hockney
Arata Isozaki
Frank Kermode
Anselm Kiefer
Oliver Knussen
Rem Koolhaas
Milan Kundera
György Kurtág
Doris Lessing
Claude Lévi-Strauss*
Antonio López García
Ian McEwan
Alice Munro
Glenn Murcutt
V.S. Naipaul
Oscar Niemeyer
Edna O'Brien
Kenzaburo Oe
Michael Ondaatje
Orhan Pamuk
Nicanor Parra
Arvo Pärt
Krzysztof Penderecki
Sigmar Polke
Gerhard Richter
Salman Rushdie
Peter Sculthorpe
Ravi Shankar
Pierre Soulages
Wole Soyinka
Tom Stoppard
Wisława Szymborska

*Died in 2009.

William Trevor
Mario Vargas Llosa
Andrei A. Voznesensky
Derek Walcott

Ngũgĩ wa Thiong'o
Christa Wolf
Yevgeny Yevtushenko
Zhang Jie

Award Committees of the
American Academy of Arts and Letters
2009